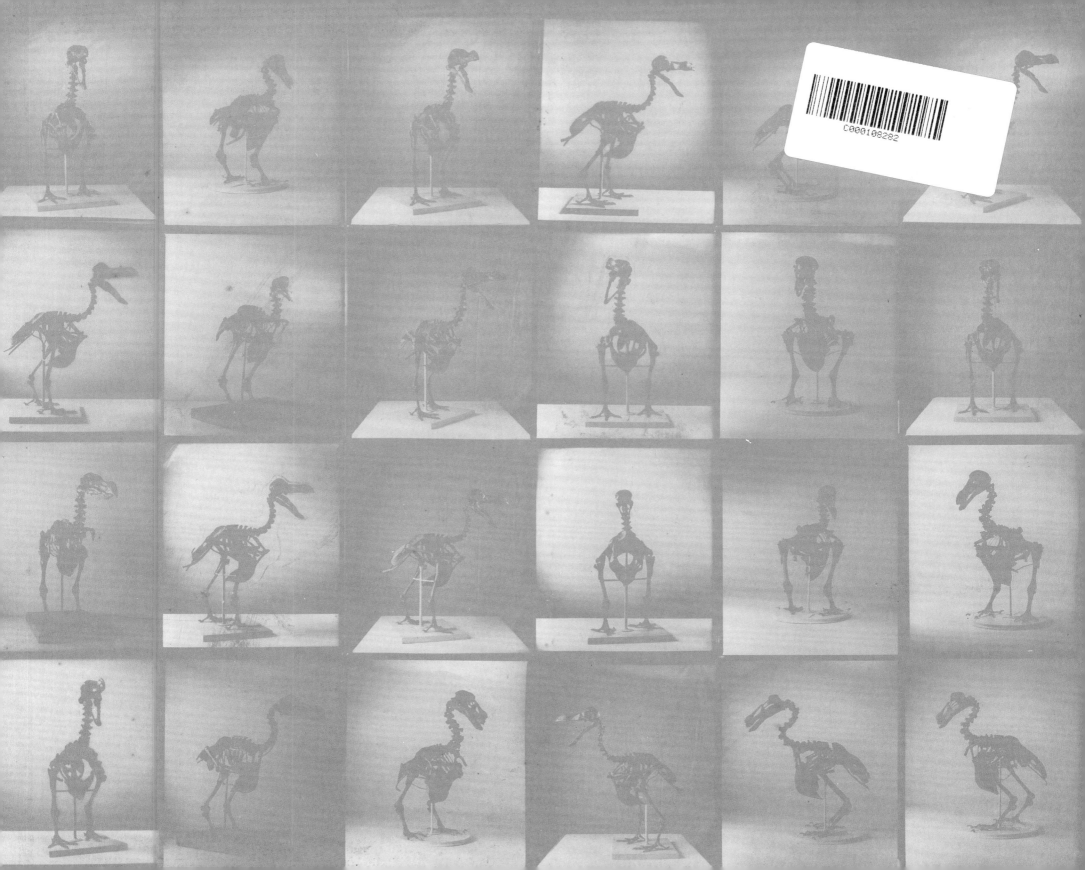

THE DODO AND MAURITIUS ISLAND
IMAGINARY ENCOUNTERS

EUROPEAN PUBLISHERS AWARD
FOR PHOTOGRAPHY 2004

11TH YEAR

JURY

JOHN DEMOS (Apeiron Photos)
Project leader for 2004

WILLIAM A. EWING (Musée de l'Elysée, Lausanne)
BENOÎT RIVERO (Actes Sud)
DEWI LEWIS (Dewi Lewis Publishing)
JONAS BRAUS (Edition Braus)
ANDRÉS GAMBOA (Lunwerg Editores)
MARIO PELITI (Peliti Associati)
GERO FURCHHEIM (Leica Camera AG)

IN COLLABORATION WITH

FIRST PUBLISHED IN THE UK IN 2004 BY

DEWI LEWIS PUBLISHING

8 Broomfield Road, Heaton Moor, Stockport SK4 4ND, England
Tel.: +44 (0) 161 442 9450

www.dewilewispublishing.com

Harri Kallio

THE DODO AND MAURITIUS ISLAND
IMAGINARY ENCOUNTERS

DEWI LEWIS
PUBLISHING

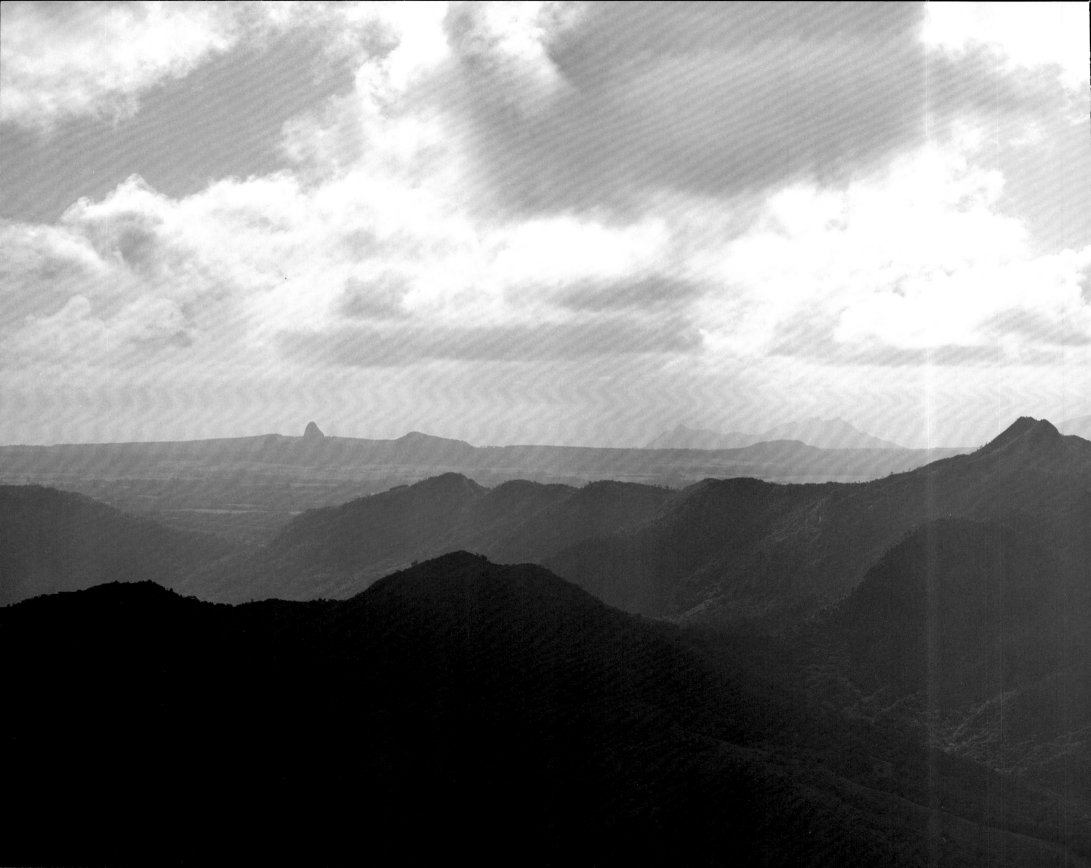

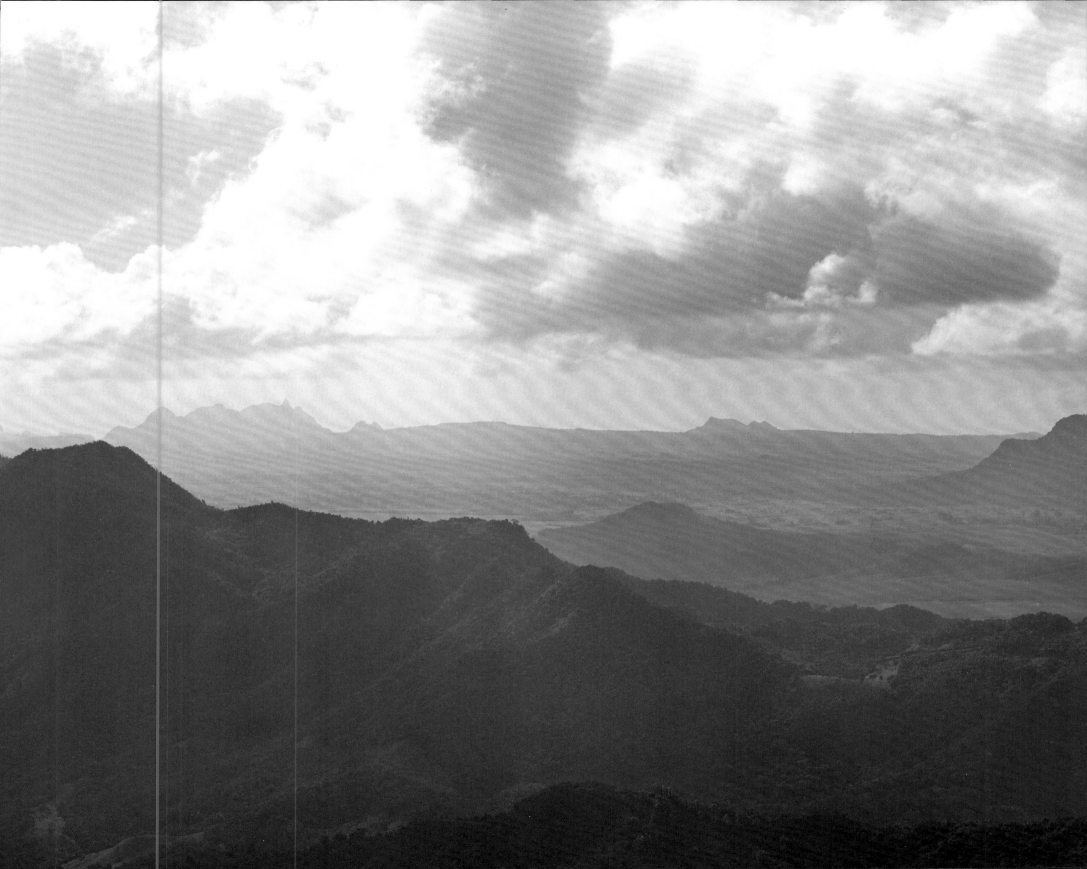

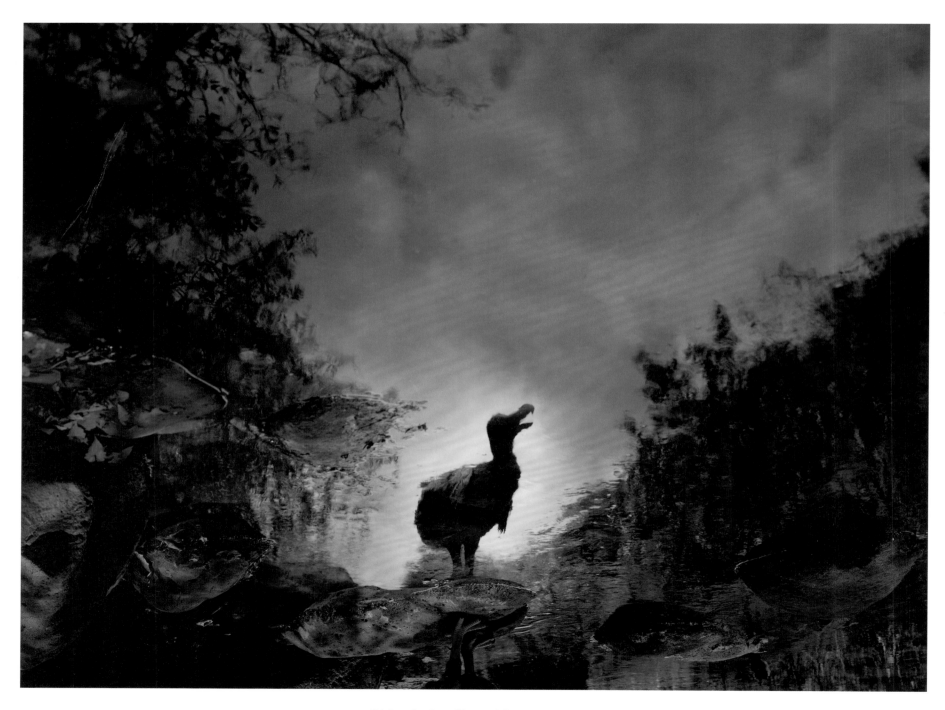

Riviere des Anguilles #3, Mauritius, 2001

CONTENTS

11	FOREWORD
12	THE DODO AND MAURITIUS ISLAND: IMAGINARY ENCOUNTERS
15	THE SHORT HISTORY OF DODO COEXISTENCE WITH HUMAN SETTLERS
17	HISTORICAL AND PHYSICAL REFERENCE MATERIAL: MUSEUMS AND LIBRARIES
21	THE REMAINS OF DODOS SHIPPED LIVE TO EUROPE
29	DODO FOSSIL SKELETONS
35	EYEWITNESS ACCOUNTS
40	DODOS IN 17TH CENTURY PAINTING: PAINTINGS AND DRAWINGS AS REFERENCE MATERIAL
44	AN INTERPRETATION OF INFORMATION
49	MANUAL FOR BUILDING A DODO: SCULPTURE PROCESS AND TAXIDERMY
74	THE LOST LANDSCAPE OF THE 17TH CENTURY PARADISE ISLAND
77	WORKING WITH THE DODO RECONSTRUCTIONS IN THE LANDSCAPE
118	BIBLIOGRAPHY
119	MUSEUMS POSSESSING DODO REMAINS (*Raphus cucullatus*)

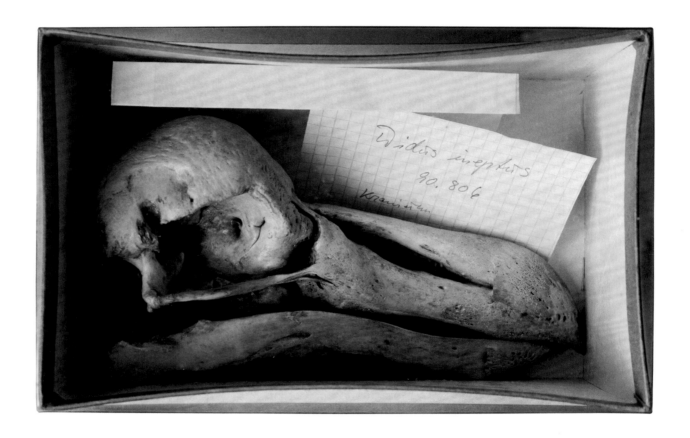

Copenhagen University Zoological Museum

FOREWORD

I s there a possible form of the past? In his work *The Dodo and Mauritius Island: Imaginary Encounters*, Harri Kallio employs photography to invent the past. This reconstruction takes place through language, illustration, photography and installation. In natural history museums we encounter presentations of animals and plants which no longer exist. Harri Kallio reconstructed a bird, the Dodo, which became extinct in the 17th century. He took two models of this bird back to its former habitat in Mauritius and recreated scenes in which the bird appears real in these surroundings. Illusionary and beguiling, it is only the knowledge that this bird was extinct before photography was even invented that may momentarily irritate the observer. But even if this deception is detected, it is not disappointment we feel, but pleasure at the successful outcome. Our perception does not enable us to discern between deception and reality. Photographs are real, but it does not mean that a photograph can not deceive. It is the context which is decisive. And if the content of a text can be made to correspond to the image depicted in the photograph, there is no reason for doubt. The texts, together with the pictures themselves, create absolutely ideal preconditions for 'constructing' knowledge.

Prof. MANFRED SCHMALRIEDE
Pforzheim University, Cologne, Germany

THE DODO AND MAURITIUS ISLAND
IMAGINARY ENCOUNTERS

'Why,' said the Dodo, 'the best way to explain it is to do it.'

Lewis Carroll, *Alice in Wonderland* (1865)

As a child, I was fascinated by Lewis Carroll's *Alice in Wonderland*, though at the time I don't think I paid particular attention to the Dodo bird in it. Many years later I reread it, and found the Dodo to be a great character. I couldn't help but laugh — somehow it was hard to believe that once upon a time there really had been something like the Dodo out there in the world.

I'm not the first person to find Dodos compelling — more books have been written about them than about any other extinct species. This strange giant pigeon was exterminated by human intervention between 1662 and 1693 on Mauritius Island — the only place it ever existed. Although it became extinct hundreds of years ago, it still lives on in the western world's collective memory, in our stories and our mythology. I soon began noticing the Dodo everywhere — in movies, in television advertisements and even on greeting cards — and became curious why this crazy bird is still so persistently present in our culture.

Although the Dodo is a popular icon, there is very little precise information as to what these strange giant pigeons actually looked like. I began to spend time in Oxford University's libraries and in the Natural History Museum in London, to gather as much information as possible. After examining all the research material I could lay my hands on, two things became very obvious — none of the sources had a solid idea about the external appearance of the Dodo, and no one had done anything similar to what I had in mind. This book provides a chance to compare the original historical sources (paintings, drawings and eyewitness accounts), the photographs of actual Dodo remains, and my interpretation of Dodos in their natural habitat, Mauritius Island.

I became fascinated by the idea of actually building bird models and seeing how they would look in the real world. I thought it would be a serious, but fun, project to work on. And I was right — as I worked on Mauritius I found myself continually laughing at the bizarre project I was doing. I knew that whatever I did with the Dodos would be fun, funny and oddly full of life.

Imaginary Encounters is a reconstruction and a photographic study of the long extinct Dodo bird. Based on extensive research, I produced life-size sculptural reconstructions, as well as a photo based visual study of actual Dodo remains. The project culminated in photographic reconstructions of the Dodo made with the models placed in their natural habitat. Though I created my photographic work in the same locations that the Dodos would have carried on their daily activities, Mauritius Island is now a very different place to what it must have been in the early 17th century. It was a daily struggle to find land still in its natural state — land not developed for crops or housing or simply marred by modern human life.

My research for the models was based on available historical and anatomical data, with an emphasis on art historical sources. The resulting photographic work is a visual interpretation of the birds in the actual locations where they once lived — an imaginary encounter between the viewer and the Dodos on Mauritius Island. My idea was not so much to carry out a scientific reconstruction, but rather to place back into the landscape of Mauritius the Dodo of *Alice in Wonderland* — a character faithful to its appearances in art history, a character that is part myth and part real. I also wanted to recreate the kind of moments that must have occurred when the settlers arrived and the birds encountered people for the first time. I became caught up by the contradiction between the historical character and the living bird and became curious as to what it might be like to combine the two — and so I decided to find out.

The Professor photographing

his pet ... Bird.

From Richard Owen's book, *Memoir on the Dodo*, 1866
'*The professor photographing his pet bird.*'

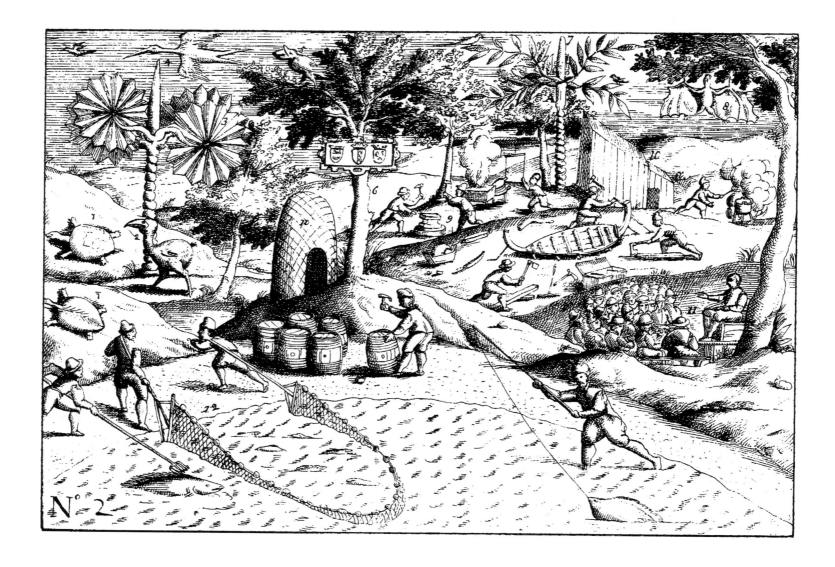

Cornelius van Neck's Travel Journal, 1601

THE SHORT HISTORY OF DODO COEXISTENCE WITH HUMAN SETTLERS

The Dodo (*Raphus cucullatus*) inhabited the island of Mauritius until the late 17th century. The island is located approximately 1000 kilometres east of Madagascar, in the middle of the Indian Ocean. Unfortunately for the Dodos, it was 'discovered' by Portuguese explorers in 1507, though it is mentioned on earlier Arabic maps and had undoubtedly been visited from very early times by Arab traders. In 1598 a group of Dutch explorers led by Jacob Cornelius van Neck took possession of the island and gave it the name Mauritius. The first written account and drawing of the living Mauritius Dodo is probably that of Cornelius van Neck, published in Holland in 1601.

'... finding in this place a great quantity of foules twice as big as swans, which they called walghstocks or Wallowbirdes not being very good meat. But finding also abundance of pigeons and popinniayes, they disdained any more to eat those great foules calling them (as before) Wallowbirdes, that is to say lothsome or fulsome birds.' — Report of expedition commanded by Jacob Cornelius van Neck, A True Report.

When European ships arrived at Mauritius, tortoises and sea turtles, along with the Dodos and other birds, provided sailors with an abundance of food and easy hunting. The Dodo was especially easy to hunt as it was flightless and, like other animals on the island 'suffering' from ecological naiveté, it had no fear of predators as it had never previously been the prey of any animal. This unfortunate lack of fear is well documented in the following eye witness description dated 1631:

'These mayors (i.e. Dodos) are superb and proud, they displayed themselves to us with a stiff and stern face and wide open mouth, very jaunty and audacious of gait and would scarcely move a foot before us, their war weapon was the mouth, with which they could bite fiercely, their food was raw fruit, they were also not well adorned, but were abundantly covered with fat, and so many of them were brought aboard, to delight all of us.' — Author unknown.

This lack of a sense of self-preservation is again confirmed in this excerpt:
'... we found no inhabitants, rather a large quantity of turtle doves and other birds, which many of us beat to death with sticks and caught, because there were no inhabitants living there who made them afraid of us, but just remained sitting, allowing us to beat them to death...' — Jacob Cornelius van Neck, 1598. published Amsterdam 1601

Despite the excessive hunting, Dodos tried to cope with the new and stressful situation in the more remote parts of the island. By the 1640s, however, when the Dutch took up occupation and set up a penal colony, the Dodo population was already in serious trouble. The bird now also had to deal with both newly introduced animal species and with the destruction of its habitat through deforestation. Pigs, monkeys and rats, amongst other introduced species, soon impacted severely on the Mauritian ecosystem, creating a spectacular population explosion in an environment lacking any native predators. One traveller who visited the island in 1709 reported having seen up to 4,000 monkeys in one glance. The same visitor also told of an eighty-man hunting party killing a thousand wild pigs in a day in an attempt to reduce the population. The presence of the new predators was especially devastating for the Dodo, as it nested on the ground and its eggs and chicks were therefore easy targets.

The extinction of the Dodo probably took place between 1662 and 1693. A few individual birds were reported to be seen by Volquard Inverness in small islets in a lagoon off the east coast of Mauritius in 1662, but no later writer mentions any live specimens. Apparently the Dodos eventually learned to run away from their predators — though a little too late:

'We also found here many wild goats and all kinds of birds which are not at all timid, perhaps since they are not used to seeing people who hunt them. They stood quite still and watched us and allowed us to approach them. Among them were the birds known to the Indians as Dodders, which are larger than geese, but unable to fly, having only little stumps of wings, but are fast runners. One part of us would chase them so that they ran towards the other party who then grabbed them. When we had one tightly gripped around the leg it would cry, then the others would come to its aid and could be caught as well.' — Volquard Inverness, 1662.

Frenchman Francis Legit, who stayed on the island in 1693, compiled an extensive list of the native birds that includes no mention of the Dodo. Only a few decades had elapsed since the island's permanent occupation in the 1640s, and the extermination of the Dodo. By 1693 at the latest, a wonderful, peculiar species of gentle creature had ceased to exist.

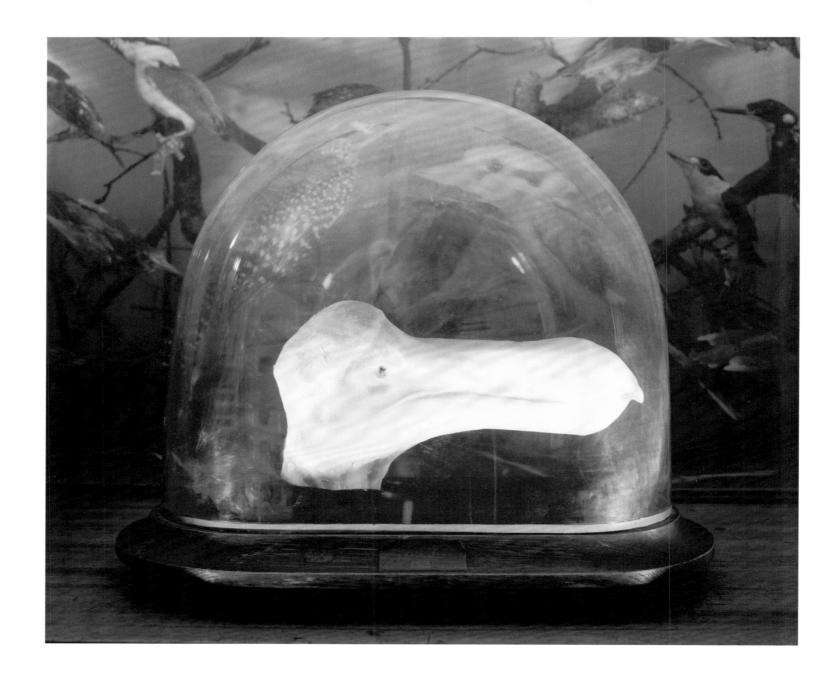

Wax cast of a Dodo head. Oxford University Natural History Museum

HISTORICAL AND PHYSICAL REFERENCE MATERIAL
MUSEUMS AND LIBRARIES

Several different source materials are available as reference to determine the external appearance of the Dodo: actual remains, eyewitness accounts, paintings and drawings. In addition, more books have been published about Dodos than about any other single extinct species. The first monograph *Dodo and its kindred*, Strickland & Melville, was published 1848. Combining these sources, a reasonably complete idea about the Dodo's appearance can be established — though there is much room for interpretation, and some aspects remain in the realm of 'educated guesswork'.

No one will ever know exactly what the Dodo looked like, as the available remains do not contain sufficient usable DNA to enable cloning. It is possible, however, to utilise the available historical and anatomical data to underpin interpretations and reconstructions which can come reasonably close. In my case, I chose to emphasise certain pictorial sources.

Using concrete fossil data and the actual remains as a guide, it was possible to ascertain fairly accurate body dimensions, and anatomical details such as the head and feet. For all other external details, however, I had to rely on the pictorial sources and the eye witness accounts, which unfortunately gave vague and conflicting information.

For my project to continue, a fundamental choice had to be made: whether to depict Dodos as overweight, slow creatures or as more athletic, agile birds. Analysis of available reference material shows evidence supporting both points of view. It seems that the popular visual notion of the bird may be a misunderstanding, or at least a slightly unfair version of what was actually a more lean figure. This notion of the Dodo as fat and dumb may live on in our collective memory, but it appears to emanate from a single source — the Dutch painter Roelandt Savery.

Savery's Dodo paintings and drawings are the most important pictorial source for the reconstruction of details such as the feathers and general coloration of the bird. He seems to be one of the few artists who actually worked with a live Dodo — most later imagery appears to have been copied direct from Savery, or in some cases from copies of Savery copies resulting in inevitable caricature. The most widespread image is John Tenniel's illustration in Lewis Carroll's *Alice in Wonderland*, which is also based on Savery's paintings.

THE CONCRETE EVIDENCE, PHYSICAL DODO REMAINS

Two types of Dodo remains exist — those imported to various cities in Europe and elsewhere, and subfossils excavated in Mauritius during the 1860s. Practically all the fossil material now in museums was excavated from one location in southeast Mauritius — a swamp area called La Mare aux Songes. Some fossils were also excavated from caves in a mountain area called Le Pouce. No complete mounted specimen exists. All the 'stuffed Dodo specimens' in the various museums are reconstructions or models, and as far as this study is concerned all are secondary sources. All that is left of the actual birds today is a head, one skull, one foot, a cast of a foot, some pieces of skin and a collection of subfossils — some of which are put together as composite skeletons.

The remains imported to Europe are located in four museums: Oxford University Natural History Museum, The Natural History Museum, London, Copenhagen University, and Narodny Museum, Prague. Dodo skeletons that have been put together using fossil remains are located in dozens of natural history museums around the world. There is also an egg, which the East London Natural History Museum in South Africa claims to be the only Dodo egg in existence. However, the museum's reluctance to expose this specimen to detailed DNA analysis, and the uncomfortably large size of the object for a Dodo-sized bird, cast doubt on its authenticity.

Excellent lithographs depicting actual Dodo remains in great detail were published widely in 19th century literature. I preferred, however, to see the objects myself, in order to get as much anatomical information as possible for my reconstructive sculpture work. My photographs of these remains also serve as a visual catalogue of what little has been left behind.

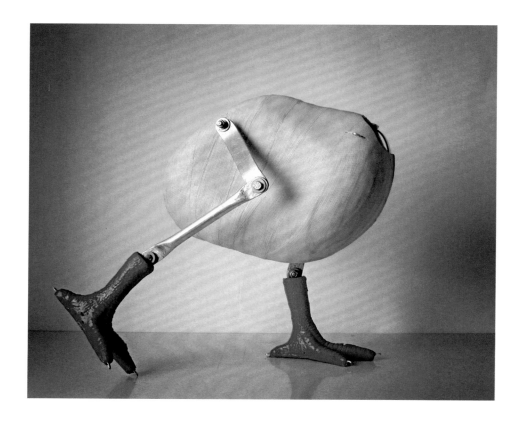

Several birds were shipped alive to Europe and elsewhere. Historical document-ation suggests that there were live Dodos in Prague, London and Amsterdam sometime in the early 17th century. Dodos in Surat (India) and Nagasaki (Japan) were also likely.

Sir Hamon Lestrange wrote a description of a Dodo he saw in London:
'About 1638, as I walked London streets, I saw the picture of a strange fowle hong out upon a cloth, and myselfe with one of two more then in company went in to see it. It was kept in a chamber, and was a great fowle somewhat bigger than the largest Turkey Cock, and so legged and footed, but stouter and thicker and of a more erect shape, coloured before like the breast of a young cock fesan, and on the back of dunn or deare coulour. The keeper called it a Dodo, and in the ende of a chymney in the chamber there lay a heape of large pebble stones, whereof hee gave it many in our sight, some as a bigg as nutmegs, and the keeper told us shee eats them (conducing to digestion), and though I remember not how far the keeper was questioned therein, yet I am confident that afterwards shee cast them all againe.'

The photographs and notes about remains are the first part of the recon-struction references. Images of the Dodo head in Oxford and the cast of the foot in London made it possible to reconstruct the heads and feet for my sculptures. The subfossil skeleton images and notes together with the statistical background data helped me to build the mechanical models of the skeletons on a 1:1 scale. The height of a Dodo varies from 70 cm to 100 cm depending on the gender and their posture.

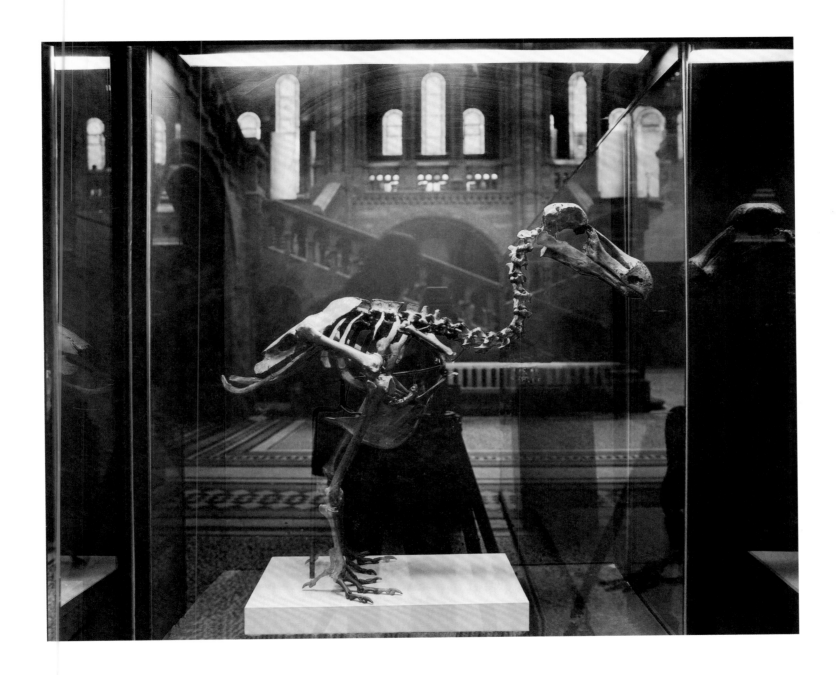

Dodo subfossil skeleton. Natural History Museum, London

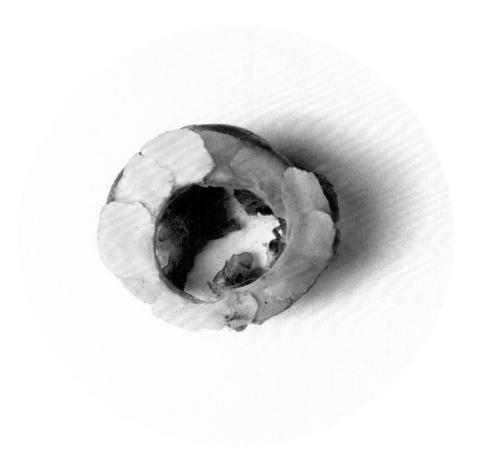

Dodo's eye. Oxford University Natural History Museum

THE REMAINS OF DODOS SHIPPED LIVE TO EUROPE

- Oxford University Natural History Museum

- Natural History Museum, London

- Copenhagen University Zoological Museum

- Narodny Museum, Prague

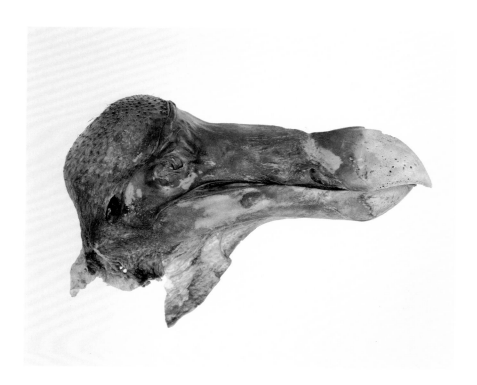
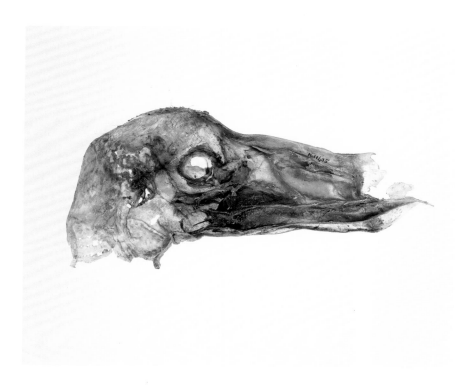

Oxford University Natural History Museum

I began collecting reference material for the reconstructions in Oxford. In the early 17th century, the University's Natural History Museum obtained the remains of a mounted specimen for their collection. All that is now left is a head, the skeleton of a foot and a few pieces of skin. According to legend, this specimen was nearly thrown out during a cleaning operation at the museum. Fortunately, someone decided to keep the head and the foot. The specimen is the best existing model for a head, and it is the only one that has any soft tissue left. Oxford (and London) also have the best libraries of early Dodo literature and other essential research material.

The Dodo head in the Oxford University Natural History Museum provides a fairly good idea of the anatomy of the bird. It has, however, dried and decayed over the years, as a result of the inadequate mounting techniques of 17th century taxidermy. This mummified relic is very fragile and holding it in my hands during the photo shoot was a very nerve-wracking, yet oddly touching experience. Handling this strange object made me wonder about the journey this individual bird had made, to end up dead in a museum display case on the other side of the world. The skin has been removed from one side of the head and the tip of the beak is missing. Also the dried state of the skin does not give any clues about the original colour. Fortunately, plaster casts were produced before the removal of the skin. This specimen was believed to be another source of inspiration for Lewis Carroll's Dodo character.

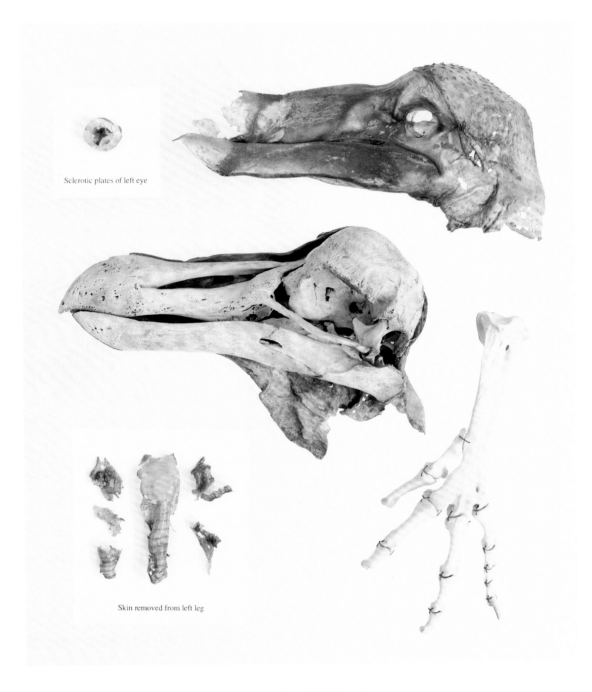

Sclerotic plates of left eye

Skin removed from left leg

The most complete Dodo in existence.
Oxford University Natural History Museum

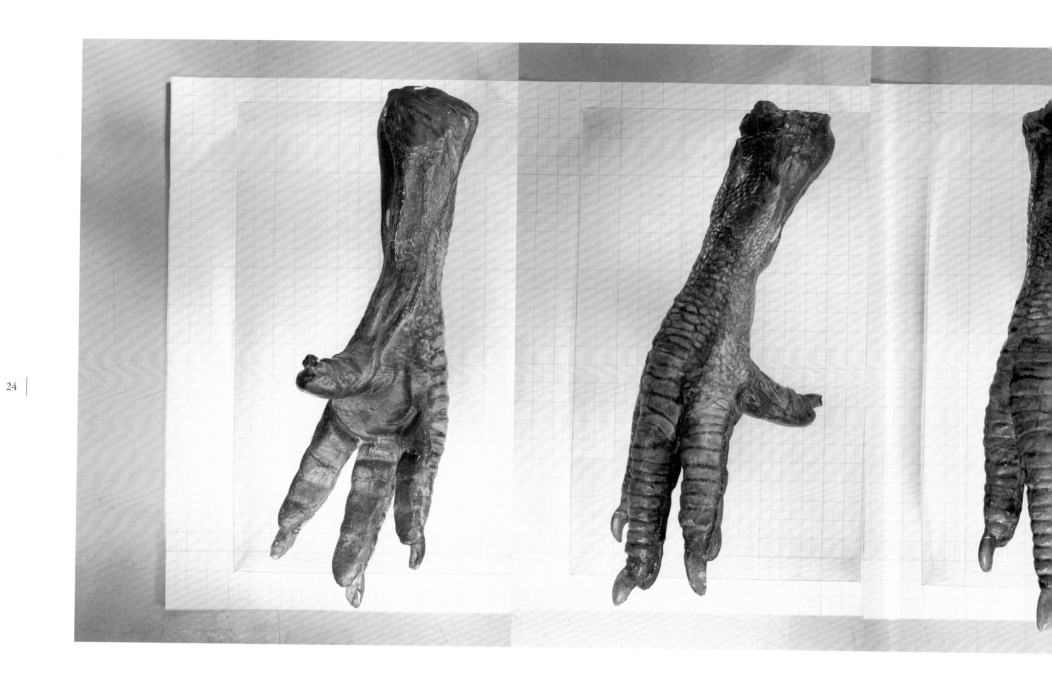

The mysterious Dodo foot. Natural History Museum, London.

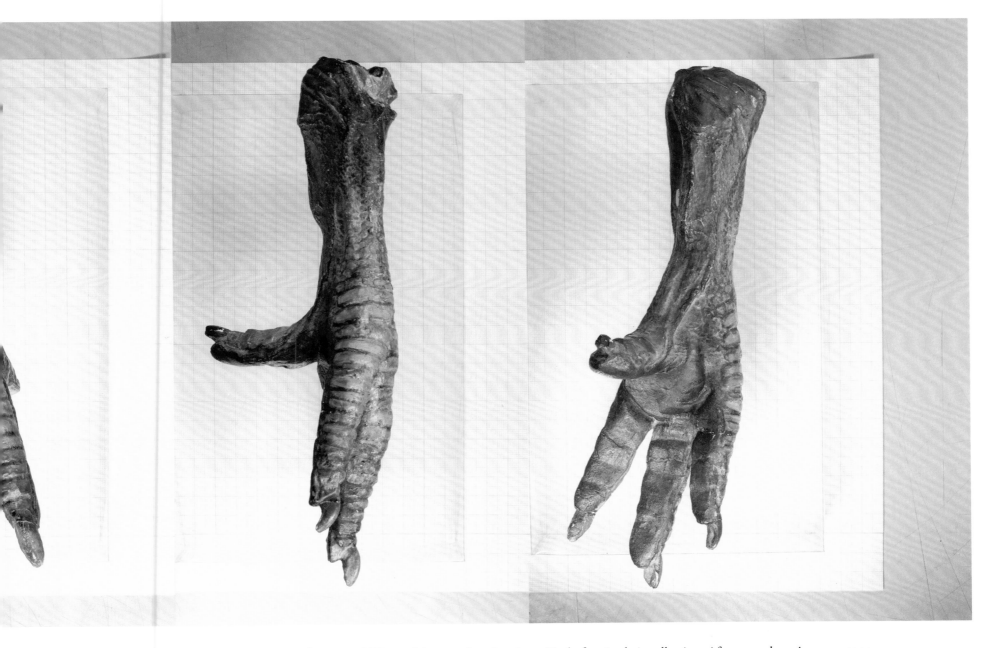

It is unclear whether or not the Natural History Museum, London, has a Dodo foot in their collection. After several evasive answers to my queries about the whereabouts of this object, it became obvious that nobody knew where it was located. The original object seems to be lost somewhere in the vast collection rooms of the museum. Fortunately there is an excellent cast available, which has been painted to match the original colour. The cast of the foot provides a very detailed and clear idea of what a Dodo's foot must have looked like.

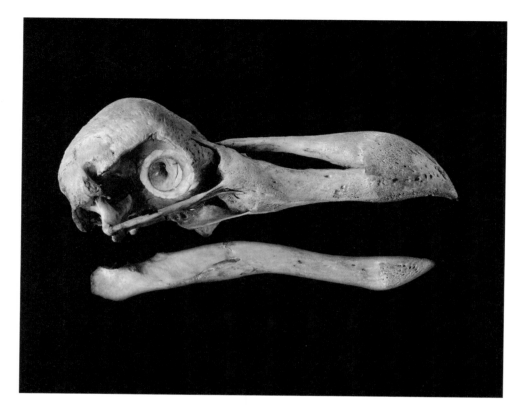

Copenhagen University's Zoological Museum

Copenhagen University's Zoological Museum

Copenhagen University's Zoological Museum has a Dodo skull in its collection. There is no soft tissue left, though there is a part of the eye included. The origin and the history of this specimen is unknown — yet another mysterious journey from Mauritius Island to Europe.

Narodny Museum, Prague

The Narodny Museum, Prague, has a small collection of Dodo bones — a tip of a beak and the bones of one leg. Somehow, the diminished number of remaining pieces of this individual seems to underline the fact that so much of its story is also missing. These bones are probably remains of a mounted specimen that was once a part of Rudolf II's famous collection of natural history curiosities.

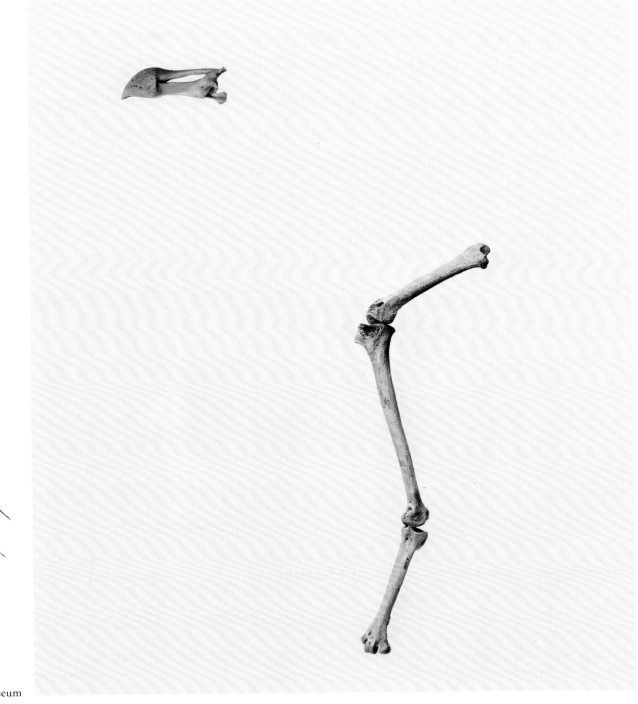

Prague, Narodny Museum

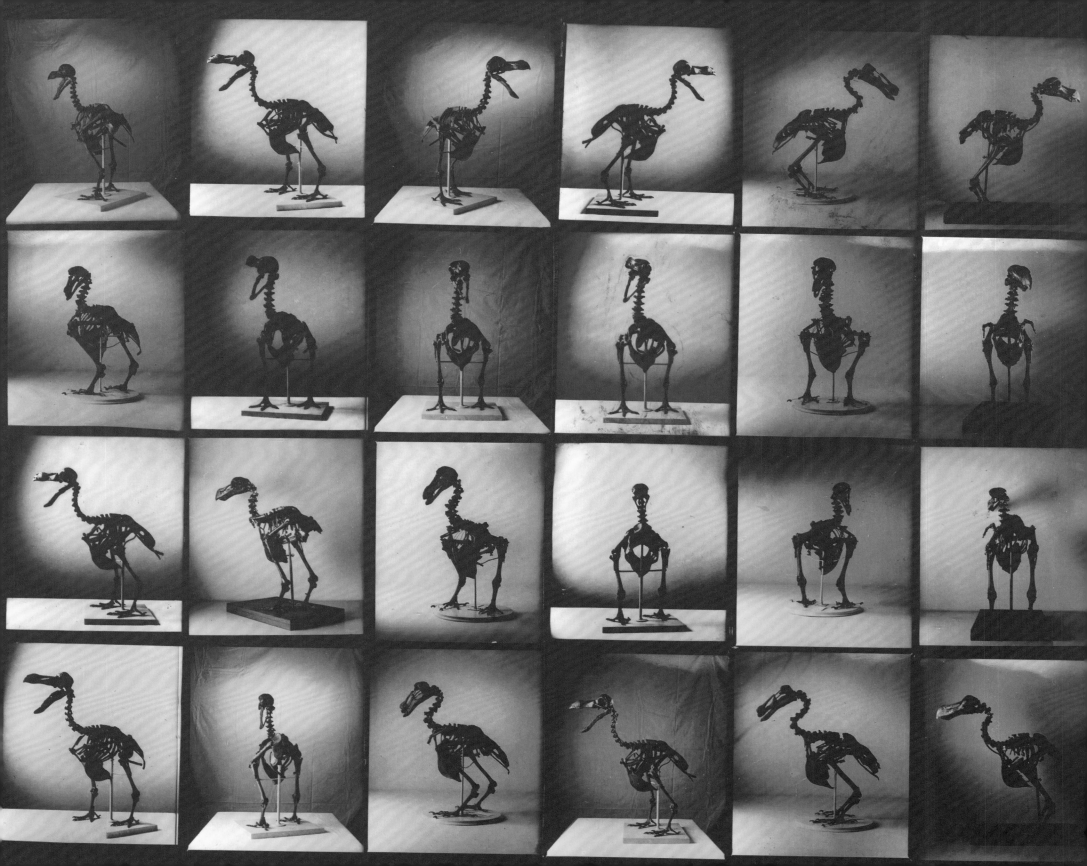

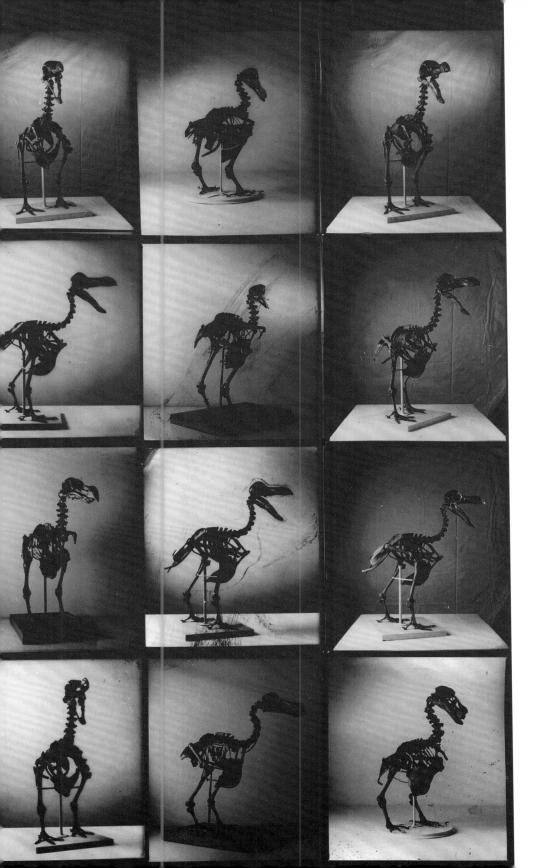

Cambridge University, Department of Zoology

Natural History Museum, London

Walter Rothschild Zoological Museum, Tring

Dodo Fossil Skeletons

Cambridge University Natural History Museum has an extensive collection of Dodo fossils, as well as the most famous fossil skeleton. This was constructed using Roelandt Savery's Dodo painting (*Edwards Dodo*) as a guide, resulting in a somewhat strange crouching pose.

The Natural History Museum, London, has three Dodo fossil skeletons in its collection. One is displayed in the museum lobby, and the other two are in storage facilities — one in London and the other in Tring, where the Walter Rothschild Zoological Museum is located.

On the following pages some of the skeleton photographs have a transparent silhouette of the finished Dodo reconstruction superimposed. This is to enable the potential anatomy of the Dodo to be visualised in reference to the composite skeletons.

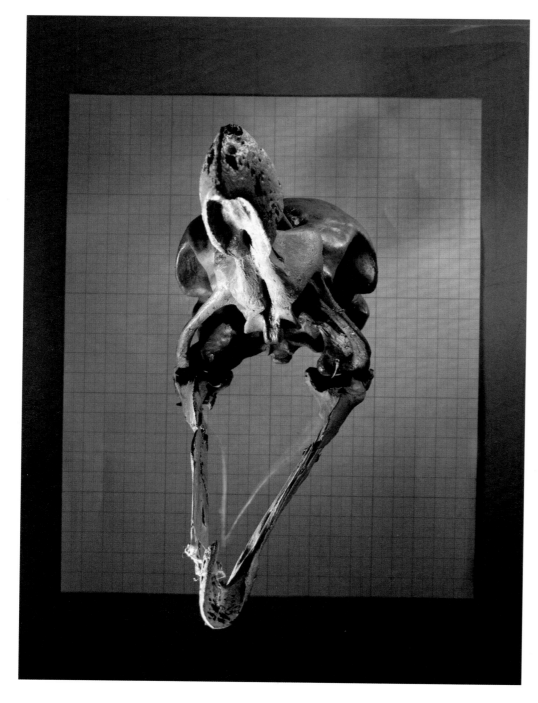

Natural History Museum, London

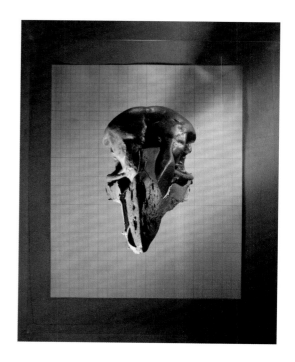

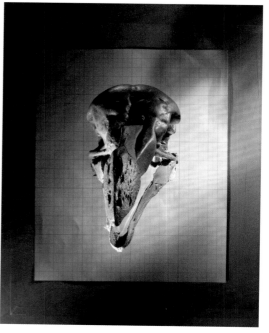

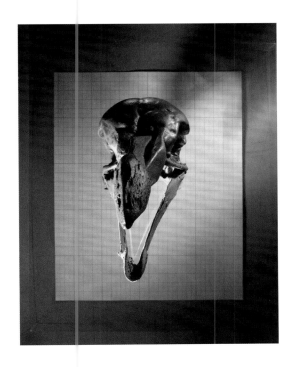

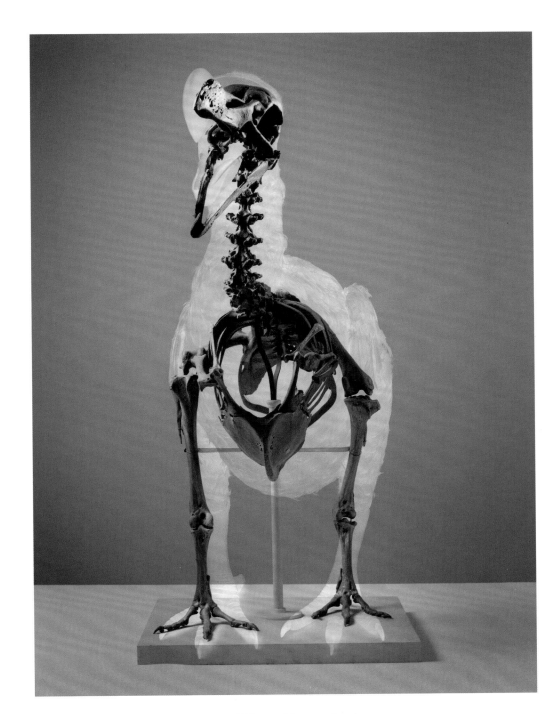

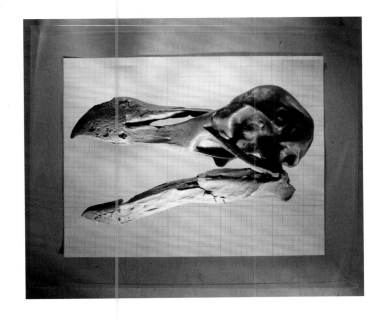

Natural History Museum, London

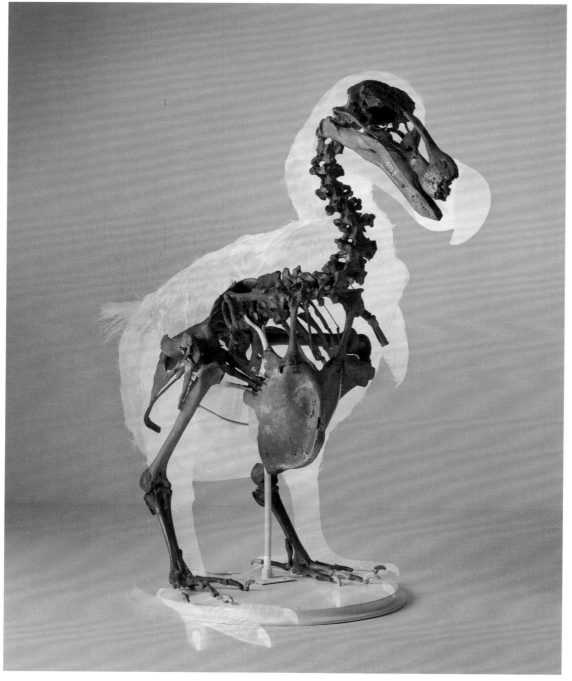

Cambridge University, Department of Zoology

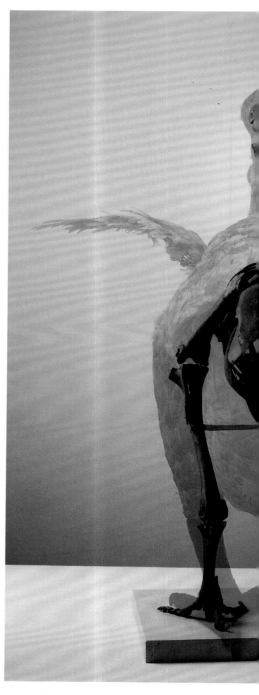

Natural History Museum, London

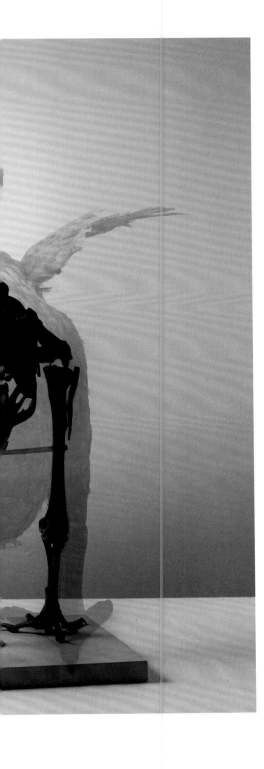

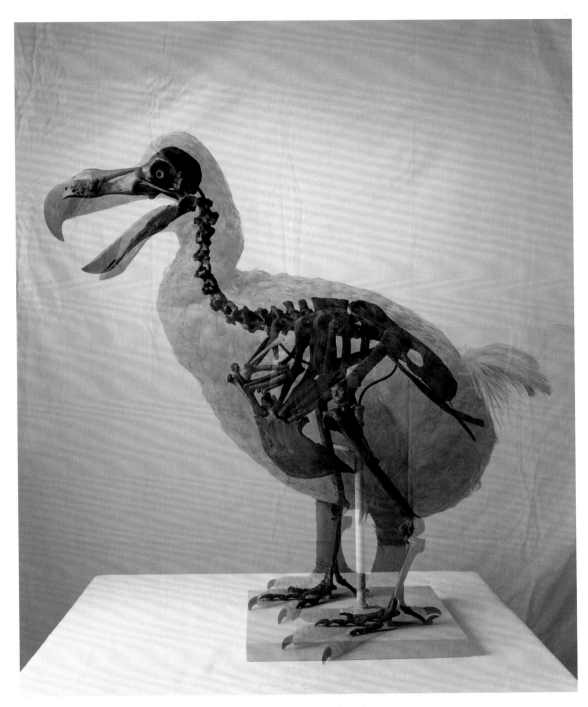

33

Natural History Museum, London

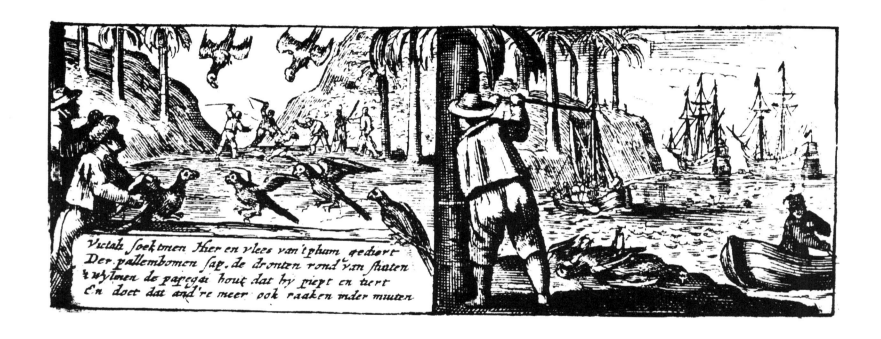

Willem van West Zanen, 1602.

'For the food the seamen hunt the flesh of feathered fowl.
They tap the palms, the round sterned dodes they destry,
The parrots' life they that he may scream and howl,
And thus his fellows to imprisomment decoy.'

EYEWITNESS ACCOUNTS

The next important sources for building the reconstructions were the numerous eyewitness accounts describing different aspects of feathers, plumage, wings, tail and coloration. Even though Portuguese explorers visited Mauritius first, they left no written accounts and it was the Dutch sailors who wrote the majority of these.

Eyewitness accounts are often vague and contradictory. It is also impossible to determine whether some, from the same period of time, are more reliable than others. It was common in 17th century travel writing and documentation to create stories of fantasy creatures. Some are also directly copied from other people's accounts, an apparently acceptable practice in the 17th century scientific world. The traveller's accounts have a tendency to emphasise the culinary aspects of their encounters with new animals, rather than observe their behaviour or appearance. This was perhaps understandable from the point of view of hungry sailors — sailors who had been eating crackers and fish and drinking only water for months on end during their journeys across the uncharted oceans of the time.

Drawing conclusions about eyewitness accounts requires comparative analysis. If a certain aspect — such as the overall coloration of plumage — is repeated, then it is more likely to be valid. Furthermore, it is useful to compare these observations with the pictorial sources.

Many of the earlier writers used several different names to refer to the bird: Walgvogel, Walgh-vogel, Tottersten, Dronte and Dodo. The first writer to use the name 'Dodo' was Sir Thomas Herbert in 1627.

Jacob Cornelius van Neck, 1598. (A True Report, Amsterdam 1601)

'There is a bird that we called a Walgvogel, twice as big as a swan, with a round rump with two or three curled feathers on it, they have no wings, but instead there are three or four black quills, we caught a few of these as well as some turledoves and other birds… we cooked this bird, but it was so tough that we could not cook it through, but had to eat it half cooked…'

This excerpt from van Neck's journal gives little information about the appearance of Dodo, though it clearly exaggerates its size, '…twice as big as a swan…'. The account gives some details about the tail and wings, but mostly it is a complaint about the unsuitable nature of Dodo flesh for human consumption.

Willem van West Zanen, 1602.

'…The figure of these birds is given in the accompanying plate; they have great heads, with hoods thereon; they are without wings or tail, and have only little winglets on their sides, and four or five feathers behind, more elevated than the rest. They have beaks and feet, and commonly in the stomach a stone the size of a fist…'

Carolus Clusius, Exoticum Libri X, 1605 (based on the Jacob Cornelius van Neck expedition journal)

'A foreign kind of cock. Of those eight ships which sailed from Holland in April, 1598, five came in sight of a mountainous island for which they gladly steered. While staying in the island, they noticed various kinds of birds, and among them a very strange one, of which I saw a figure rudely drawn in a Journal of that voyage which they published after their return, and from which the figure at the head of this chapter is copied. This foreign bird was as large or larger than a Swan, but very different in form: for its head was large, covered as though with a membrane resembling a hood; the beak too was not flat, but thick and oblong, of a yellowish colour next the head, with the extremity black, the upper mandible hooked and curved, and in the lower was a bluish spot between the yellow and the black. They said that it was covered with few and short feathers, and had no wings, but, in place of them, four or five longish black quills. The hind part of the body was very fat and thick, and in place of a tail were four or five crisp curled feathers of a grey colour. Its legs were thick rather than long, the upper part as far as the knee covered with black feathers, the lower part and the feet yellowish; the feet were divided into four toes, the three longer ones directed forwards, and the fourth, which was shorter, turned backwards, and all of them furnished with black claws. The sailors called this bird in their own tongue, Walgh-vogel, that is, disgusting bird, partly because after a long boiling its flesh did not become more tender, but remained hard and indigestible, (except the breast and the stomach which they found of no despicable flavour) partly because they could get plenty of Turtle-doves which they found more delicate and savoury; it is therefore no wonder that they despised this bird and said that they could readily dispense with it. They said further that in its stomach certain stones were found, two of which I saw in the house of that accomplished man, Christian Porretus; they were of different forms, one full and founded, the other uneven and angular, the former an inch in

length, which I have figured at the feet of the bird, the latter larger and heavier, and both of a greyish colour. It is probable that they were picked up by the bird on the sea-shore and then devoured; and not formed in its stomach.'

Clusius's account is full of useful details. In addition, many of the structural observations in this account are repeated in other accounts: 'large or larger than a Swan, the upper mandible hooked and curved, covered with few and short feathers, upper part as far as the knee covered with black feathers, the lower part and the feet yellowish; the feet were divided into four toes, the three longer ones directed forwards, and the fourth, which was shorter, turned backwards, and all of them furnished with black claws.'

'After I had written down the history of this bird as well as I could, I happened to see in the house of Peter Pawius, Professor of Medicine in the University of Leyden, a leg cut off at the knee, and recently brought from Mauritius. It was not very long, but rather exceeded four inches from the knee to the bend of the foot; its thickness, however, was great, being

Clusius Dodo drawing, 1605

nearly four inches in circumference, and it was covered with numerous scales, which in front were wider and yellow, but smaller and dusky behind. The upper part of the toes was also furnished with single broad scales, while the lower part was wholly callous. The toes were rather short for so thick a leg; for the length of the largest of middle one was not much over two inches, while that of the next to it was barely two inches, of the hind one and inch and a half. The claws of all were thick, hard, black, less than an inch long, but the claw of the hind toe was longer than the rest, and exceeded an inch.'

This description of the Dodo foot was very useful in my reconstruction. The cast in the Natural History Museum, London, did not provide any information about the original coloration of the foot, but Clusius describes the Dodo's foot colour as yellow, and also determines the exact dimension of the claws.

Pieter Willem Verhoven, 1611
'There were also many birds such as Turtle-doves, grey parrots, rabos farcados (forked tails), Field hens, partridges, and other birds in size to swans, with large heads. They have a skin like a monk's cowl on the head, and no wings, but in place of them about 5 or 6 yellow feathers; likewise in place of a tail there are 4 or 5 curled feathers. In colour they are grey. Men call them Tottersten or Walckvögel; they occur there in great plenty, in somuch that the Dutch daily caught and eat many of them. For not only these, but in general all the birds are so tame that they killed Turle-doves as well as the other wild pigeons and parrots with sticks, and caught them by hand. They also caught Totersen or Walckvögel with their hands, but were obliged to take good care that these birds did not bite them on the arms or legs with their beaks, which are very strong, thick and hooked; for they are wont to bite desperately hard.'
Published 1613 in Frankfurt

Verhoven's account of the bird's body size seems realistic. It has been established (using the subfossil skeleton data) that the Dodo's body size is slightly bigger than a swan. Interestingly, Verhoven's description of the other details matches Roelandt Savery's painting (*Edwards Dodo*) very closely. Several other eyewitness accounts have very close similarities, such as the description of wings: 'no wings, but in place of them about 5 or 6 yellow feathers'. Towards the end of his account, Verhoven gives a description of the bird's character which contradicts the common notion of the helpless, stupid and slow Dodo. According to his account, they were very capable of defending themselves.

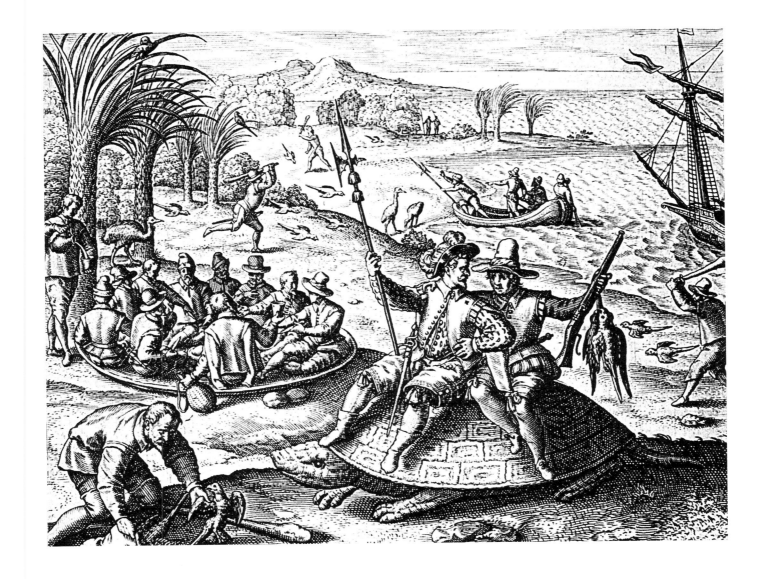

De Bry's journal, *India Orientalis*, Frankfurt 1619

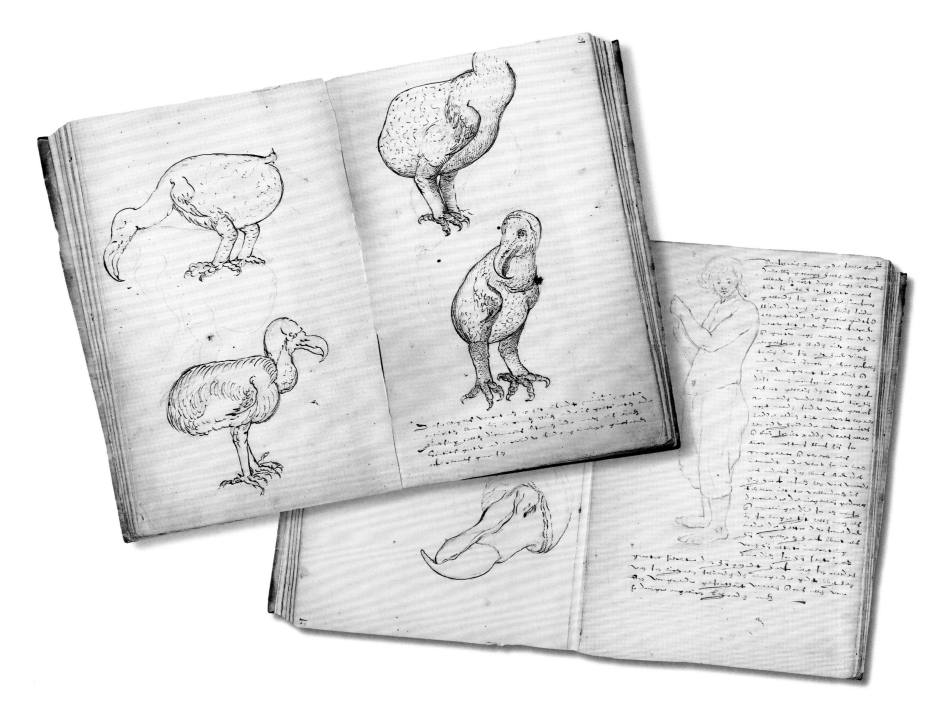

Wolfert Hermanszoon, travel journal, 1601-03, the Hague, Algemeen Rijks Archief

Sir Thomas Herbert, 1627

'Her body was round and fat which occasions a slow pace; a few of them weigh less than fifty pounds – meat is with some – but better to the eye than stomach, being indeed more pleasurable to look than feed upon. It is of a melancholy visage as sensible of nature's injury in framing so massive a body to be directed by complemental wings, such indeed as are unable to hoist her from the ground, serving only to rank her amongst birds. Her head is variously dressed with down of dark colour – the other half naked, and of a white hue, as if lawn were drawn over it. Her bill, hooks and bends downwards; the trill, or breathing place, is in the midst, from which part to the end the colour is of a light green mixed with pale yellow. Her eyes are round and bright and, instead of feathers, has a most fine down; her train like a china beard, is no more than three or four short feathers; her legs are thick and black; her talons great; her stomach fiery, so that she can easily digest stones; in that and shape not a little resembling ostrich.' (T. Herbert 'Some years travel to divers parts of Africa and Asia the great', published 1677 in London, first published 1634.)

Sir Thomas Herbert was the first to use the name Dodo in print, and his account contains several useful details. He describes the upper extremity of the beak as bending downwards. The head feathers are described as darker than the rest of its plumage. Herbert also examines the coloration of the head, which is the most contradictory and vague portion of many accounts. I found the most interesting observation to be that Dodo feathers are more downy than most feathers. Sensibly, a flightless bird does not need streamlined feathers that are suitable for flying. This view is repeated in several other texts, with several travellers comparing Dodo plumage to that of an ostrich.

Francois Cauche, 1638

'I have seen in Mauritius birds bigger than a swan, without feathers on the body, which is covered with a black down; the hinder part is round, the rump adorned with curled feathers as many as the bird is years old. In place of wings they have feathers like these last, black and curved, without webs. They have no tongues, the beak is large, curving a little downwards; their legs are long, scaly, with only three toes on each foot. It has a cry like a gosling, and is by no means so savoury to eat as the Flamingos and Ducks of which we have just spoken. They only lay one egg which is white, the size of a halfpennyroll, by the side of which they place a white stone the size of a hens egg. They lay on grass which they collect, and make their nests in the forests; if one kills the young one, a grey stone is found

in the gizzard. We call them Oiseaux de Nazaret. The fat is excellent to give ease to the muscles and nerves.' (*Relation veritables et curieuses de l'Isle Madagascar*, Paris 1651)

Cauche's account is probably the most unusual. Many details are probably inaccurate, such as the idea that the Dodo has as many tail feathers as years lived. Cauche also observed that Dodos had only three toes, which is certainly untrue.

Gulielmi Piso, 1658

'Of the Dronte of Dodners. Among the islands of the east indies is reckonded that which by some is called Cerne, and by our countrymen, Mauritius, most famous for its black ebony. In this island a bird of wonderful form, called Dronte, abounds. In size it is between an Ostrich and a Turkey, from which it partly differs in form and partly agrees, especially with the African Ostrich, if you regard the rump, the quills, and the plumage; so that it seems like a pygmy among them in respect of the shortness of its legs. The head is large, clumsy, covered with a membrane like a hood. The eyes are large and black; the neck curved, prominent, and fat; the beak remarkably pointed and hooked. The gape is hideous, enormously wide, as though formed for gluttony. The body is fat, round, and clothed with grey feathers in the manner of Ostriches. On each side, in place of quills, it is furnished with small feathered wings, of a yellowish grey, and behind the rump, in place of tail, with five curved plumes of the same colour. The legs are yellow, thick, but very short; the toes are four, stout, long, scaly, and the claws strong and black. The bird is slow and stupid, easily taken by the hunters. Their flesh, especially that of the breast, is fat, eatable, and so abundant that three or four Drontes have sometimes sufficed to feed a hundred seamen. If not well boiled, or old, they are more difficult of digestion, and when salted, are stored among the ship's provisions…'

Piso's account is very much the same as Verhoven's (1611). Wings, tail feathers, feet and plumage are described in the same manner. In addition, the structure of the beak seems similar to Piso's account.

These accounts provided a good starting point for building a list of those qualities and structures that seem most accurate. I was able to make conclusions about the body, feathers, wings, tail feathers and the specific colour of different parts of the body. The next stage was to compare these observations with the pictorial sources – the paintings and drawings that were most likely created using live birds as models.

Dodos in 17th Century Painting
Paintings and Drawings as Reference Material

It is impossible to be certain which 17th century paintings and drawings were made using live birds as models. Some authors presume that almost all of the paintings are authentic (Oudemans, 1917; Hachisuka, 1953), but there is no substantial proof to support their views. It is possible that some painters used live Dodos as models, but is is just as likely that they were produced from memory, or copied from other paintings. There are only a handful of artists that could have realistically worked using a live model. In these few cases, there is some historical documentation or other information to support the possibility of authentic Dodo depictions. Most other existing paintings and drawings seem to have been copied from earlier images, and lack reliable historical background information about their origin and authenticity.

ROELANDT SAVERY AND 'EDWARDS DODO'

Most people have at least a vague idea of what Dodos looked like, and this image is mainly derived from paintings. The most famous Dodo image is John Tenniel's anthropomorphic drawing in Lewis Carroll's *Alice in Wonderland* (1865). Tenniel used Roelandt Savery's painting *Edwards Dodo* (1626) as an inspiration for his character. This painting is stored in the Natural History Museum, London. As it served as Tenniel's model, and is the picture most commonly copied by other artists (Ziswiler, 1996), it is the most important pictorial reference.

Savery's Dodo painting, *Edwards Dodo*, is the most detailed and well known in which the artist used a live bird as a model. Savery (1576-1639) was a Dutch painter, who was especially famous for his Dodo paintings. The artist, George Edwards, gave this painting to the Natural History Museum London collections, stating that Savery had produced it in Holland using an actual Dodo as a model, and that Sir Hans Sloane, the previous owner of the painting, had shared this information with him (Broderip, 1866).

Savery worked for Rudolf II in Prague in 1604, and at that time, according to several sources, there was a live Dodo in Prague. Daniel Fröschl, who was responsible for cataloguing Rudolf II's art and natural history curiosity collection, lists a mounted Dodo as one of the items in the collection in 1607-1611. The remains that are still in Narodny Museum in Prague are probably of this specimen.

Savery produced at least a further eight Dodo paintings, most of which were painted in Holland some time after 1626, so that he must either have used the sketches produced during his stay in Prague, or was working with a live model in Amsterdam.

The details in the painting are very close to several eyewitness accounts. Verhoven's (1611), Nieuhof's (1682) and Piso's (1658) accounts of Dodos come very close to the character that this painting depicts. Details such as the structure and colour of the wings and tail feathers, the colour and down-like quality of the plumage and details of the head and feet are all very close.

Similarly interesting work by Savery is his *Dodo studies* (1626) which he most likely made in Amsterdam. A confusing detail in the sketch is that both

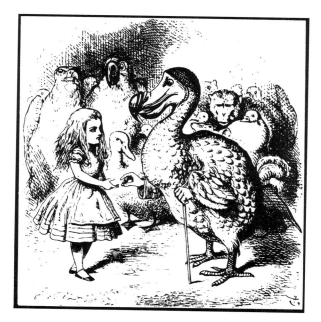

John Tenniel's Dodo,
Lewis Carroll, *Alice in Wonderland*, 1865

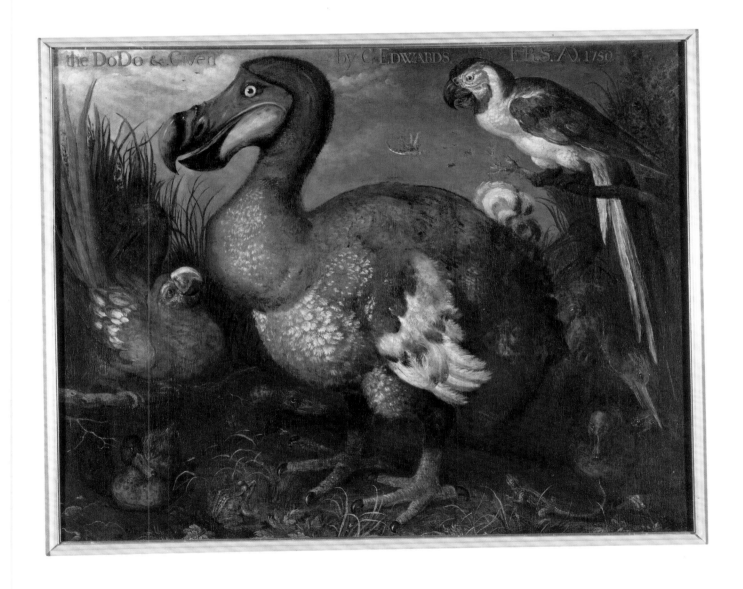

Roelandt Savery, *Edwards Dodo*, 1626
Natural History Museum, London

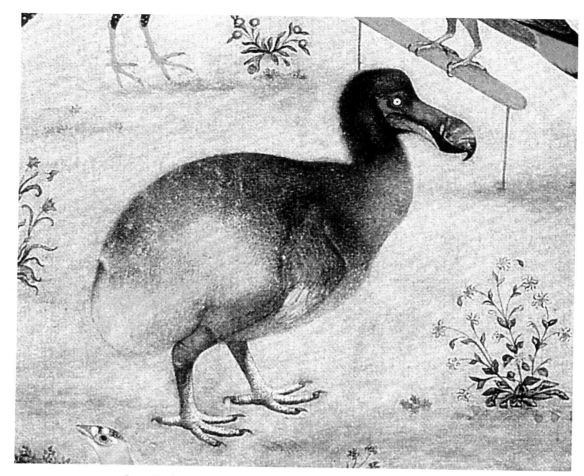

Surat Dodo,1625 (detail), Institute of Oriental Studies, St Petersburg

characters in the picture seem to have webbed feet. The cast of the foot in London does not give any reason to assume that a webbed foot would be part of the Dodo's anatomy.

Savery's other paintings depicting Dodos are typically allegoric 17th century images. In these the Dodo is just one of dozens of animals that all appear to be living together in an earthly paradise. These paintings usually visualise a mythological or biblical theme, as in the paintings *Paradise* that features Adam and Eve, or in *Orpheus taming the animals*.

OTHER PICTORIAL SOURCES

Adriaen Pieterzoon van de Venne (1589-1662) made an ink drawing of a Dodo in Amsterdam in 1626. The picture has a caption underneath: '*This is a faithful portrait of a Walckvogel (Dodaers it was called by our sailors because of it's prominent behind) which was transported alive from the island of Mauritius, as it was seen in Amsterdam in the year 1626.*'

It is possible that Savery's *Edwards Dodo* was painted using the same individual as a model. This image features the same odd crouching posture as the bird in Savery's painting. It is likely that all the birds that were shipped to Europe and

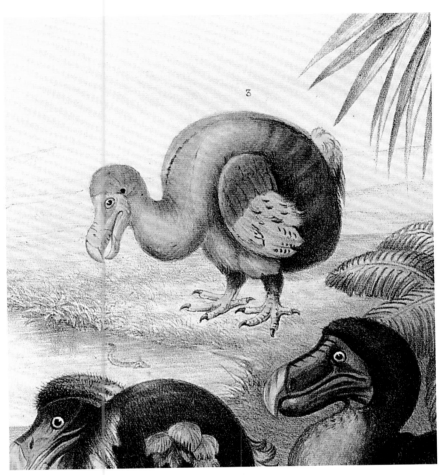

Roelandt Savery 'Landscape with birds', 1628. Kusnthistorisches Museum, Wien

Roelandt Savery 'Landscape with Dodo and Condor', 1626. Zoological Society, London

elsewhere suffered the consequences of an unnatural diet as well as long streches in cramped cages on the ships. This is probably why they seem so overweight and have such an awkward pose. When comparing images made on Mauritius and those executed in Europe and India, the Dodos that travelled are considerably heftier and fatter.

Wolfert Hermanszoon's travel journal (1601-03, The Hague, Algemeen Rijks Archief) has first-hand drawings of Dodos. These are from the same period as the pictures in van Neck's journal, but have been executed in a much more detailed manner. The birds in these images are also noticeably leaner than in Savery's and van de Venne's pictures.

In addition to these pictorial sources, there is an image that was painted in India by Shah Jahangiri's court painter, Mansur, in 1625 in a city called Surat. This painting is exhibited in the Institute of Oriental Studies in St. Petersburg, Russia. It is part of a collection of images that were produced to document Jahangiri's collection of exotic animals. The Dodo in this painting is surrounded by other, still existing, species of birds that are convincingly painted, which suggests that this painting was made using a real Dodo as a model. Peter Mundy, a British explorer also reported having seen two Dodos in Surat in his travel journal (1628-1634).

AN INTERPRETATION OF INFORMATION
PHYSICAL EVIDENCE, EYEWITNESS ACCOUNTS AND PICTORIAL SOURCES

SKELETON RECONSTRUCTION AND THE BODY SHAPE

I used four fossil skeletons as a reference to reconstruct the body shape — the skeletons in Cambridge, London and Tring. All of these differ in terms of size and assembly. Bradley Livezey (1992) used fossils to put together statistical information about the Dodo's dimensions, both male and female, which I used to determine the exact dimensions for my reconstructions — especially the size of the head and the length of the leg bone. George Clark, an amateur archaeologist who excavated a large number of fossils from a swamp in northwest Mauritius, La Mare aux Songes, noticed that Dodo fossils seem to form two different categories in terms of their dimensions. This observation is the basis for determining the size difference between a male and a female bird.

The fossil skeleton in the Cambridge University Natural History Museum collection was put together by Richard Owen (1866) using Savery's painting *Edwards Dodo*, as a model. Owen sketched out instructions for putting together a skeleton using a silhouette outline of the character in the painting. As a result, it has a bizarre crouching position which seems quite unlikely to be accurate, especially when comparing it to Volguard Iversen's 1662 account of more agile dodos: *'… Dodderse, which are larger than geese, but unable to fly, having only little stumps of wigs, but are fast runners…'*

As stated earlier, it seems that the appearance of the Dodos shipped to Europe and other locations was different to those on Mauritius. The long journey in cramped cages and the very different diet probably made them fatter and slower than their more fortunate fellow birds still living in Mauritius. The early drawings by van Neck, Clusius and Haag, as well as the archive's images from Wolfert Hermanszoon's travel journal (1601-03) are more likely to be accurate in terms of the body weight and size.

THE SHAPE AND ANATOMICAL DETAILS OF A DODO HEAD

The most important model for the reconstruction of the Dodo head was the female head in Oxford University Natural History Museum, as well as the plaster casts produced using this head. Unfortunately, these give no clue about its original colour, and the upper extremity of the beak is missing. Other problematic areas are the inside structure, the colour of the mouth and the details of the eyes.

In the eyewitness accounts the colour and details of a head are described in numerous different and vague ways. It is impossible to make a definite conclusion based on these sources. One option is to use the information that the pictorial sources offer. Hachisuka (1953) made an analysis about the external differences between a male and female Dodo based on all the available paintings and drawings. This is a questionable approach because of the uncertain nature of this source material. It is impossible in most cases to determine whether the paintings used a live model or whether they are copies of other earlier paintings.

According to Hachisuka's analysis, a male beak has a yellowish-brown extremity and the skin covering the rest of the face is light grey. A female has a more reddish-brown extremity of the beak and the skin part of the face is blue grey or greenish. It is impossible to get definite answers regarding the details of the face or the other aspects of the external appearance. Hachisuka's conclusions, however, are very close to what we can see in Savery's paintings, which are the most important sources of reference for this project and the starting point for a legacy of copies that has formed the image of the Dodo in our collective memory.

The head in Oxford does not have the extremity of the upper beak and neither do other remaining skulls. However, this detail is described in great detail in numerous eyewitness accounts and in all the more reliable pictorial sources, so it is reasonable to assume that it was an existing structure. The best painting to be used as a reference for this detail is again Savery's *Edwards Dodo*.

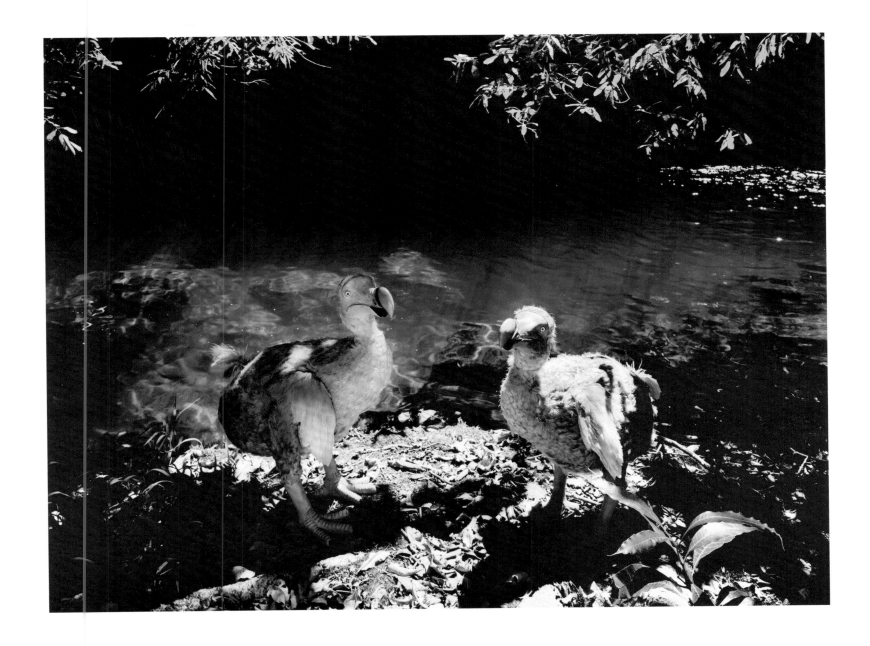

Riviere des Anguilles #1, Mauritus, 2001

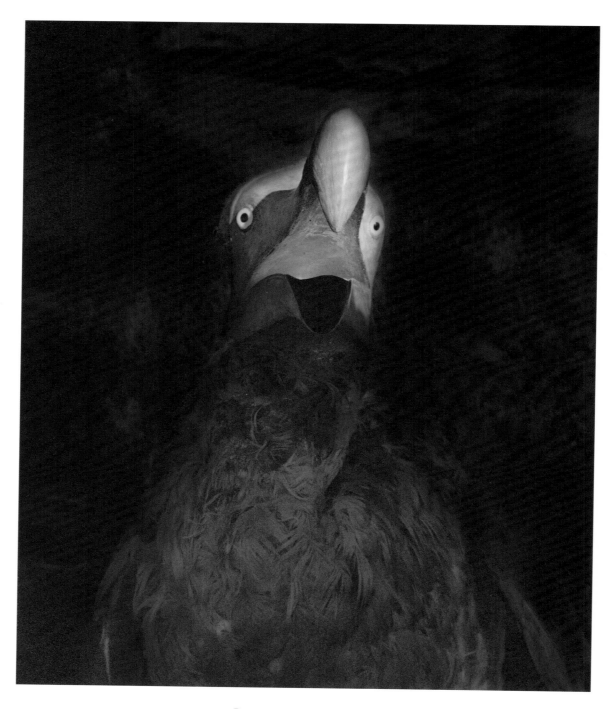

Benares #1, Mauritius, 2002

In most of the pictorial sources there is a fold-like growth between the harder part of the beak and the softer skin tissue. It is typical for birds that these kind of formations are more prominent in males than females, so I decided to make this detail more prominent for the male reconstruction.

In Savery's paintings the colour of the eyes varies from deep orange to white. In the eyewitness descriptions they are described in vague ways such as: *'Her eyes are round and bright'* and sometimes as being completely black. The most detailed and reliable reference paintings to determine this detail are Savery's *Edwards Dodo* and the painting produced in Surat, India. The eyes in both these paintings are white with a small black pupil.

The mechanical flexibility of my reconstruction designs makes it possible to open and close the beaks to enable my models to have an imaginary snack, so that the inside of the mouth also needed to have some convincing detail. According to some accounts the birds did not have a tongue. Other eyewitnesses write that *'...they displayed themselves to us with a stiff and stern face and wide open mouth...'* but still fail to offer any further detail. It would be an exceptional anomaly from the normal anatomy of birds if they had no tongue at all. In Savery's painting the beak is slightly open, and it appears that the inside of the mouth is the same colour as the rest of the face, showing hardly any clues about tongue structure.

STRUCTURE AND COLOUR OF DODO FEET

The cast of the foot in the Natural History Museum London is the best possible model for the shape of the feet. However, this cast is useless to try to determine the original colour of the feet. Clusius's account (1605) *'... and it was covered with numerous scales, which in front were wider and yellow, but smaller and dusky behind'* tells us that the colour is yellow, which is consistent with Savery's paintings and numerous eye witness accounts. Clusius also tells us the exact claw dimensions and details, *'The claws of all were thick, hard, black, less than an inch long, but the claw of the hind toe was longer than the rest, and exceeded an inch.'*

FEATHERS, WINGS AND THE TAIL

Once again, the best possible source of reference for feathers, wings and tail appearance is Savery. Several details about the colour of the feathers in his paintings are similar to other paintings and also many eyewitness accounts. It seems that the head, legs and back of this bird are darker than the rest of the body. Also, the colour of the belly and the front part of the neck seem to be of a lighter hue than the average colour of the bird.

The plumage is mostly described as grey in the eyewitness accounts. On the other hand, according to Hachisuka's analysis (1953), the male Dodo is grey and the female more grey/brown. Both versions appear in Savery's paintings. None of the eyewitness accounts talk about differences between male and female, and so it is probably a reasonable assumption that any difference is minor.

The Dodo's closest living relatives (Cooper 2002), Nicobar pigeons (Caloenas nicobarica) show similar differences between male and female individuals, along with several other members of the pigeon family such as Claravis pretiosa, a species which Hachisuka brought up as an example of the same phenomenon.

The down-like structure of Dodo feathers comes up in several eyewitness accounts. It makes sense that a flightless bird does not need streamlined feathers suitable for flying, but rather feathers to keep the body temperature constant. Many travellers compared Dodo feathers to those of an ostrich.

THE STRUCTURE OF THE WINGS AND THE TAIL

In Savery's paintings and also in several eyewitness accounts, the wings are described as being yellow or yellowish grey: *'... and no wings, but in place of them about 5 or 6 yellow feathers.'* (Verhoven 1611). Again in Savery's paintings the wings are mostly hanging on the sides like penguin wings, rather than folded and tucked away in the manner of other birds when not used for flying. This depiction of Dodo wings is more typical in the paintings of the birds shipped to Europe than the earlier ones, such as in van Neck's and Clusius's drawings. According to the traveller's accounts, the birds did not have an actual tail — just a few curly feathers in place of one. The colour of the tail feathers is mostly described as yellowish-grey or grey. This is also consistent with several paintings and drawings.

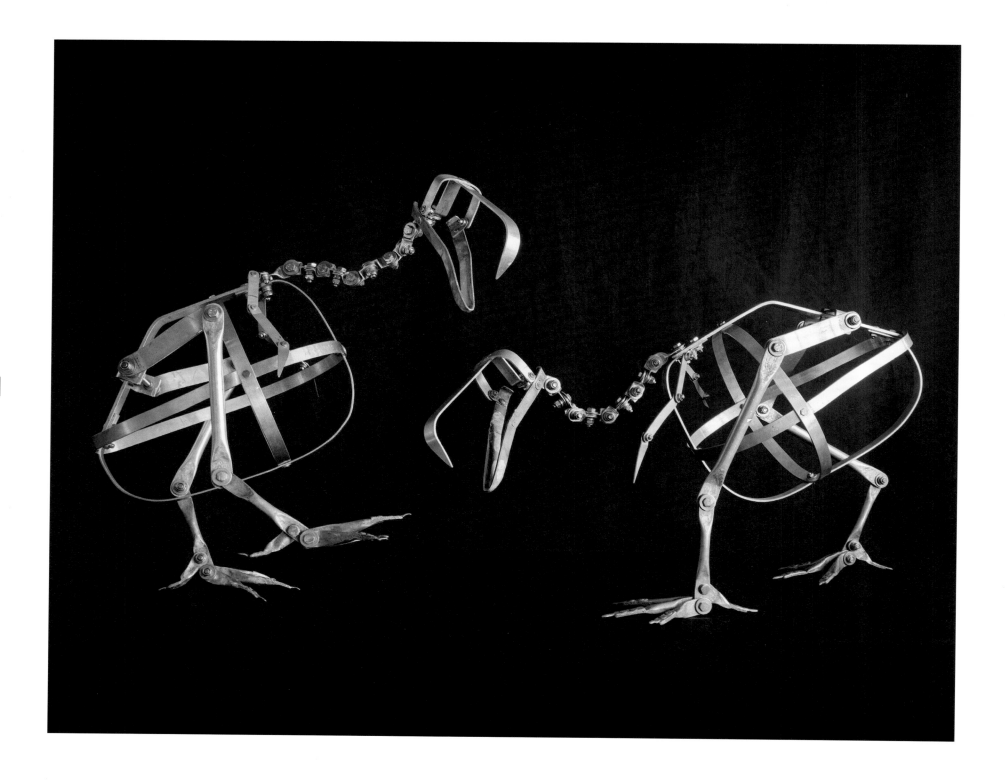

MANUAL FOR BUILDING A DODO
SCULPTURE PROCESS AND TAXIDERMY

To realise my idea, I had to construct three dimensional, life size models, one male and one female. There were several requirements to ensure that it would be possible to work with them in the hot, windy and humid Mauritius landscape. First, I wanted a construction which allowed me to adjust the pose of the characters as required. I needed adjustable joints to be able to move the necks, feet, beaks, wings and toes. A flexible folding structure was also necessary to make transportation of these sculptures possible. In addition, they had to be sturdy enough not to break during transportation and be able to cope with a humid, rainy environment. The organic parts — the feathers, wings and tails — had to be thoroughly denaturalised so that they would not begin to decompose, as it would be unacceptable to work with, and carry around, two extremely stinky Dodos. The sculptures had to be light enough so that it would be possible to carry them in the field, but also heavy enough not to fall down in the windy conditions of the island. As it happened, my Dodo models fell down numerous times anyway, resulting in aggravating emergency repair operations on site.

MECHANICAL SKELETONS, BODY SHAPE AND MUSCLES

The first stage of this sculpture project was to create the adjustable, life size skeletons. These had to offer as many adjustments as possible and hold the whole weight of the completed sculpture. The most important joints have adjustable spring and brake joints, made of aluminium and steel. All the 'bones' are forged of aluminium; the nuts, bolts and springs of stainless steel. After a month or so of experimenting, a lot of banging, some more banging and a few complaints from neighbours about excessive noise, I had in front of me something resembling a mechanical adjustable life size Dodo skeleton.

The body shape and muscles were made using dacron fibre, fibre glass, chicken wire, cotton thread and latex rubber. Using the mechanical skeleton as a base, I sculpted the body shape on it with chicken wire and covered the resulting body figure with fibreglass. When the fibreglass had cured, I sliced the cast open and removed the chicken wire from the inside. The leg and neck muscles were formed with dacron fibre and cotton thread, after which they were covered with a latex rubber layer. After more complaints from the neighbours — this time about the strange smell of latex rubber — I had something ready that resembled a pair of embarrassingly naked Dodos.

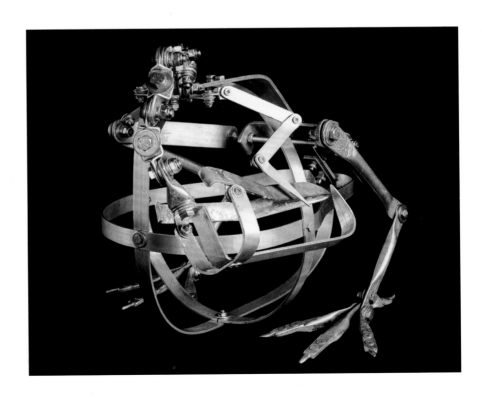

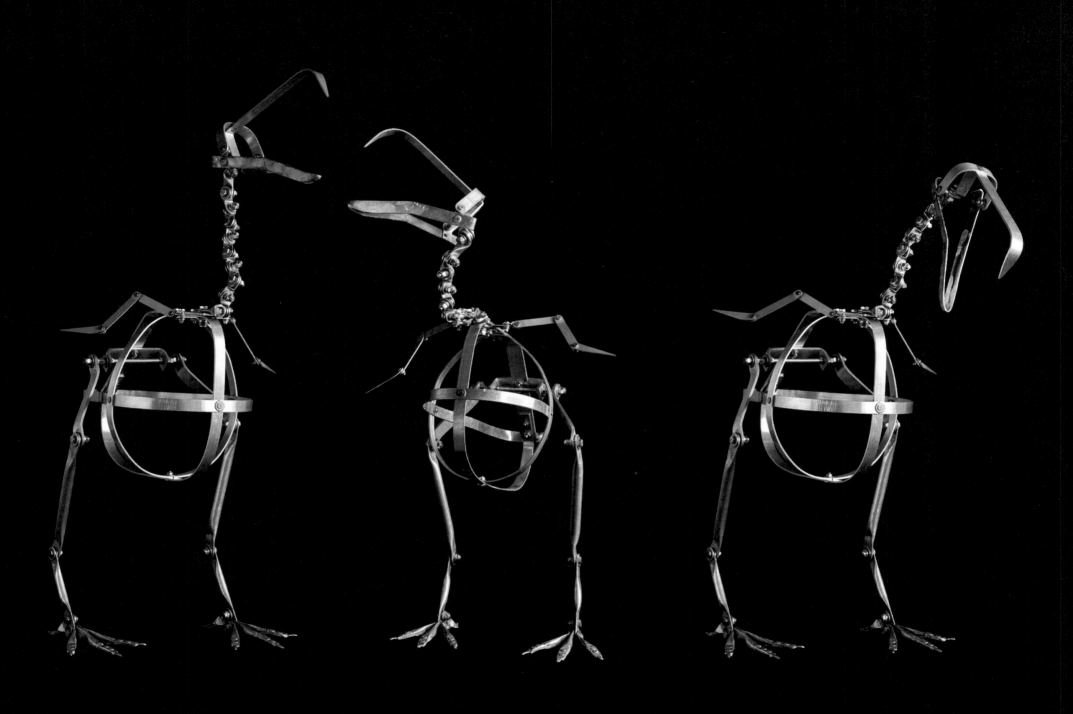

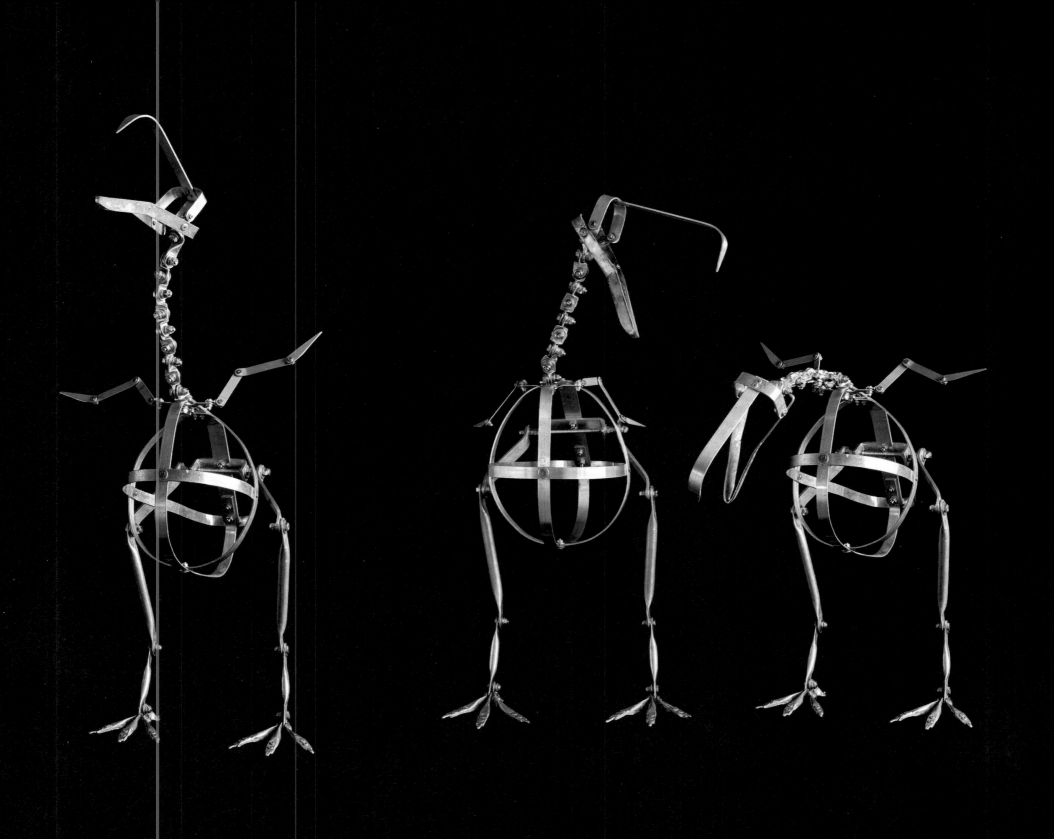

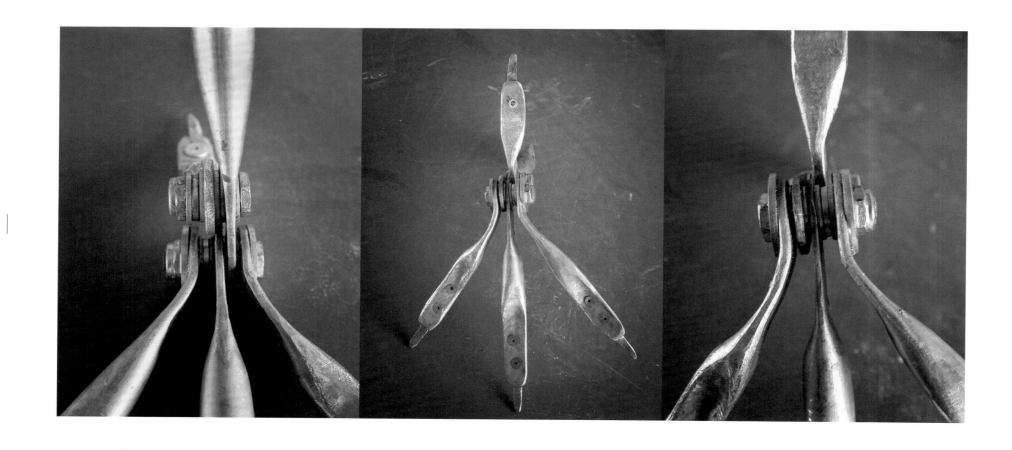

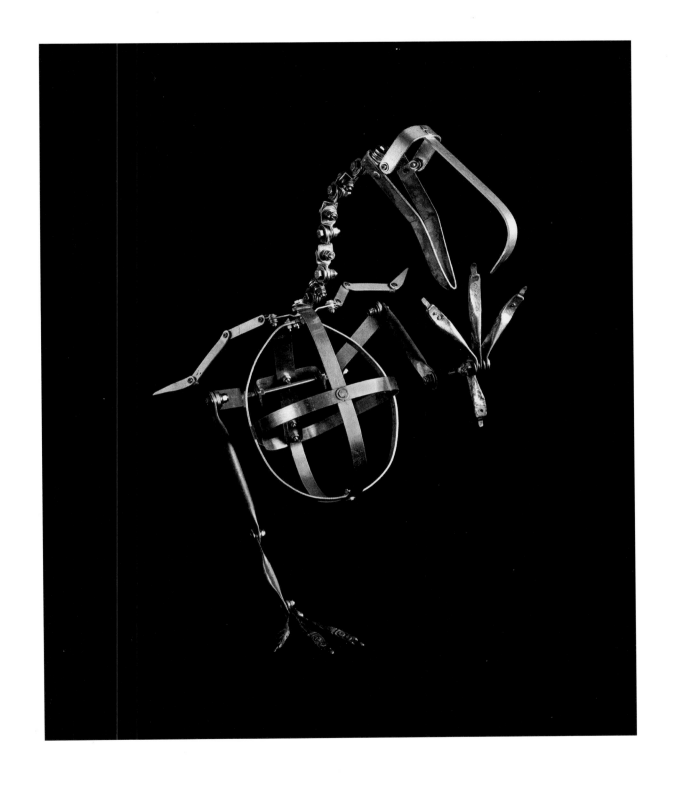

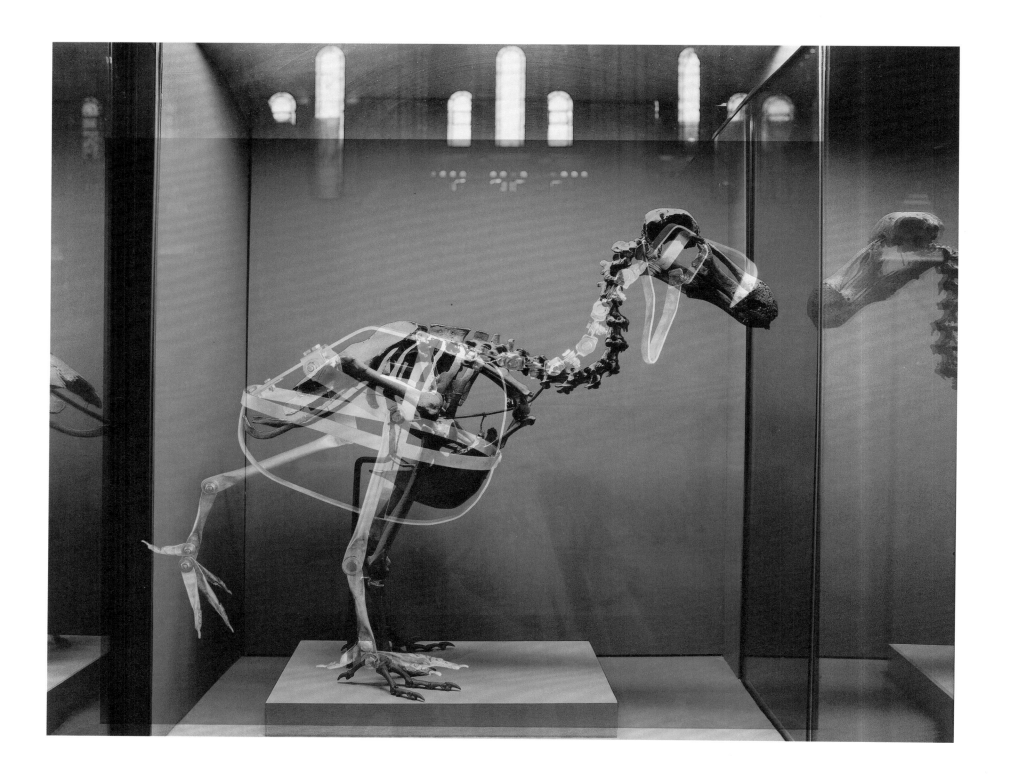

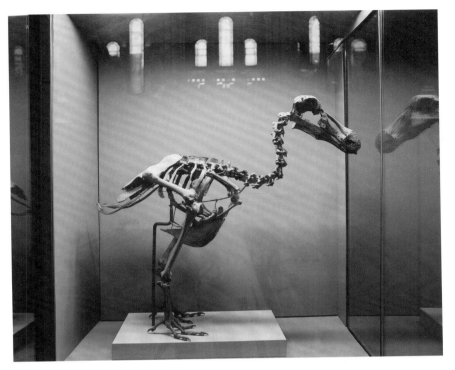

Natural History Museum, London

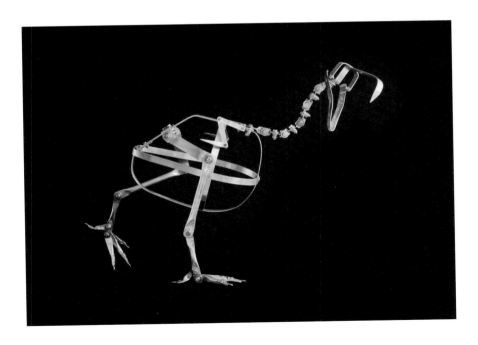

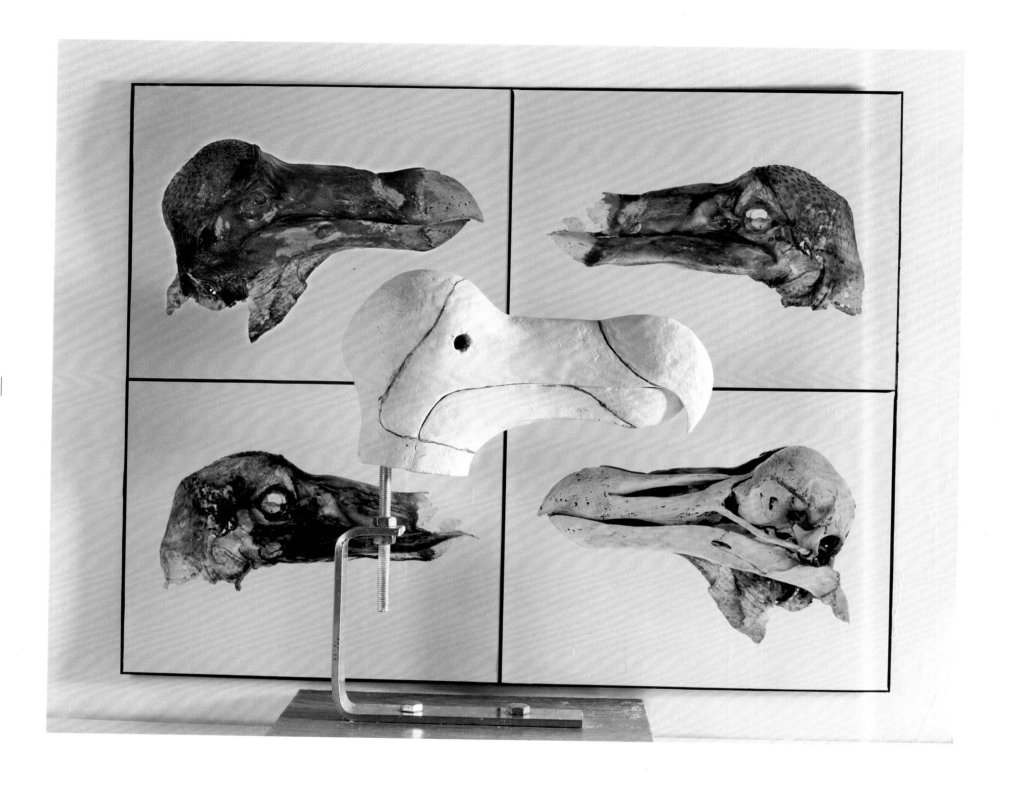

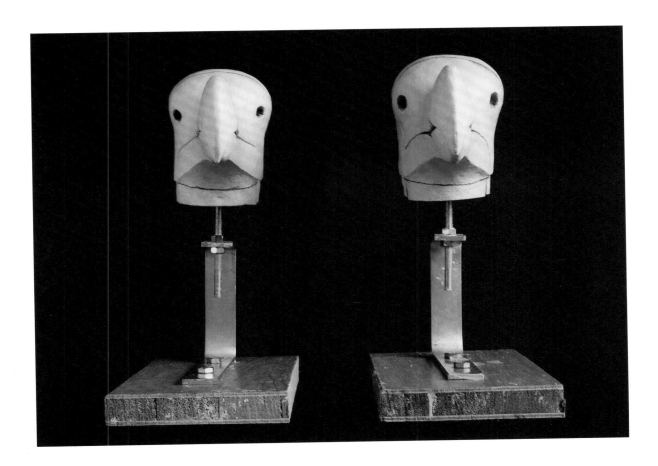

SCULPTING THE HEADS AND FEET

The next stage was to sculpt the heads, using the mechanical skeleton structures as a base and a guide for determining the head dimensions. The first stage of these sculptures was made of clay, which then evolved to a finished adjustable structure using a variety of other materials in several casting and moulding stages. I did not stop sculpting the heads until I had a feeling that they were staring at me. The materials used include plaster, polyurethane foam, and three different kinds of synthetic rubber. The final result is cast in silicon rubber, which makes the adjustable structure possible. I found eyes that matched my idea of what the Dodo's eyes would have looked like, from an online company that only sells glass eyes — including human ones.

The process of sculpting the feet and the claws was very similar to that of the heads, though somewhat simpler because it was possible to sculpt the items as one piece, rather than in two sections, as was the case with the head pieces. The claws were cast using polyester resin, pigmented black. The resulting feet looked as if they could support even a considerably overweight Dodo.

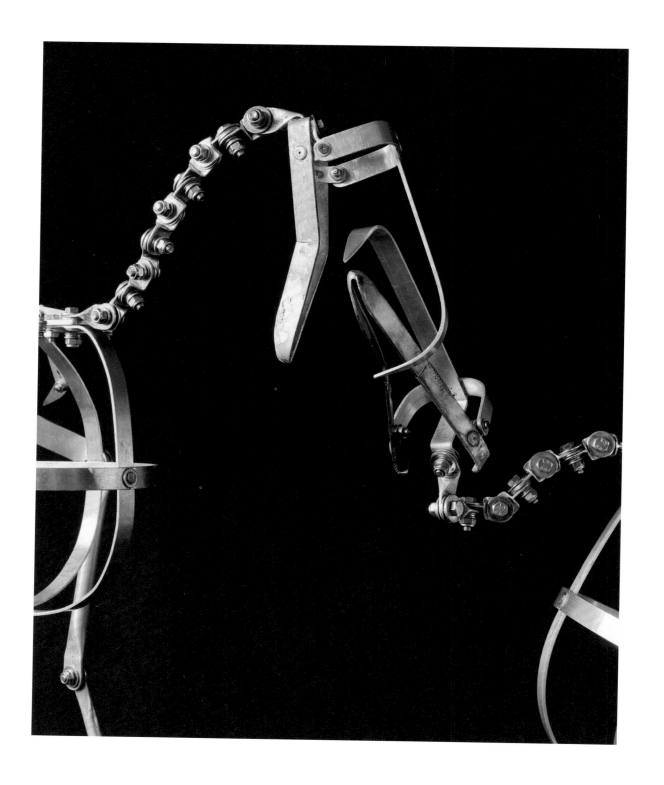

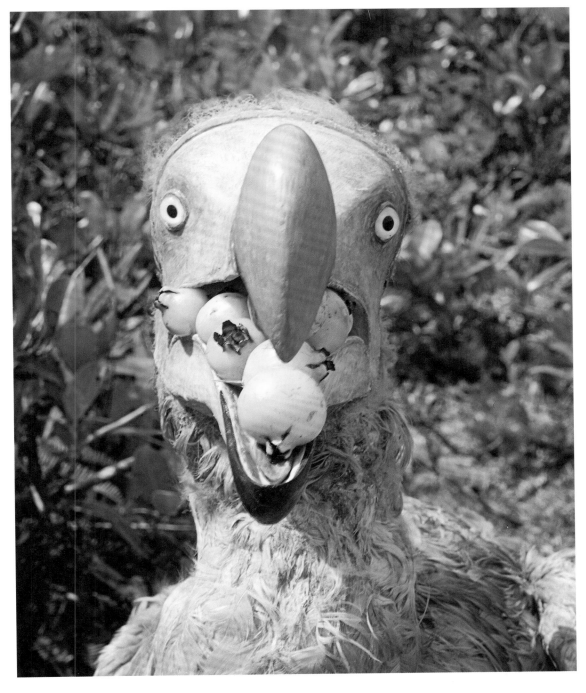

Le Petrin #2, Mauritius, 2002

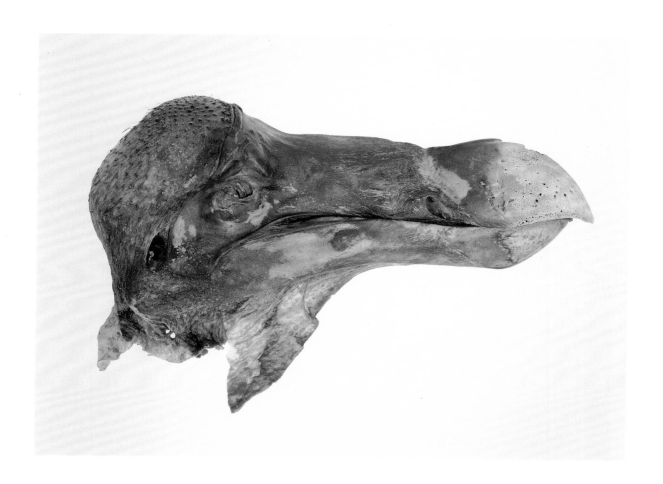

Dodo head. Oxford University Natural History Museum

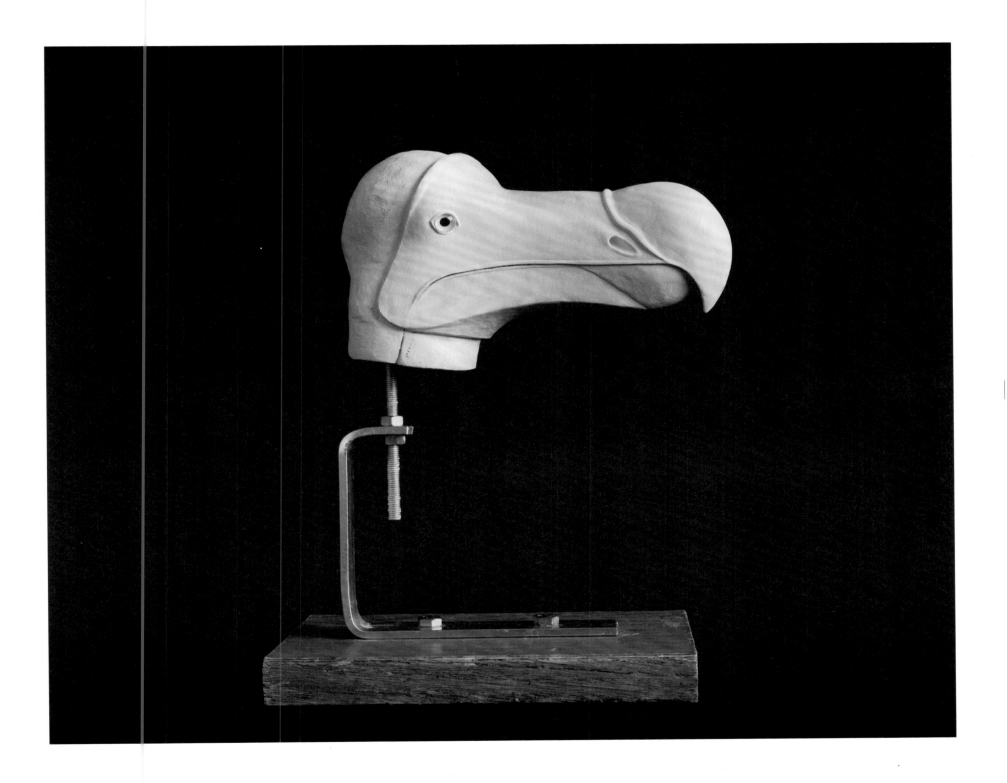

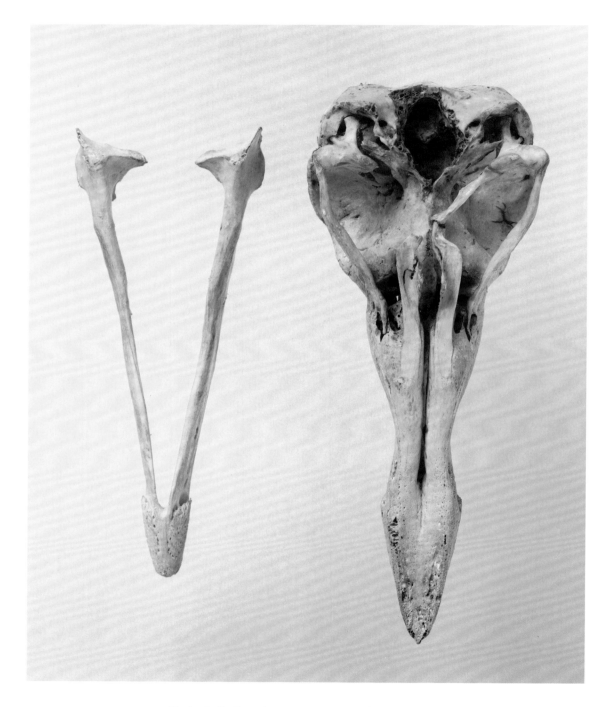

Dodo skull, Copenhagen University Zoological Museum

Natural History Museum, London

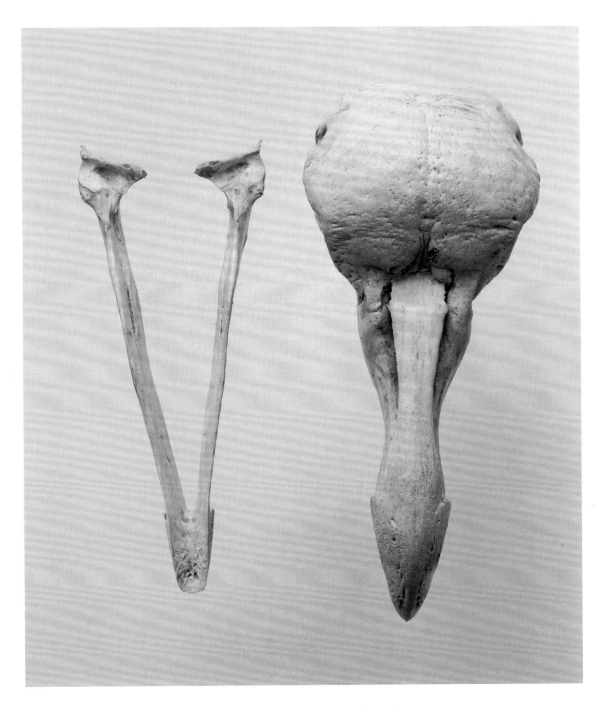

Dodo skull, Copenhagen University Zoological Museum

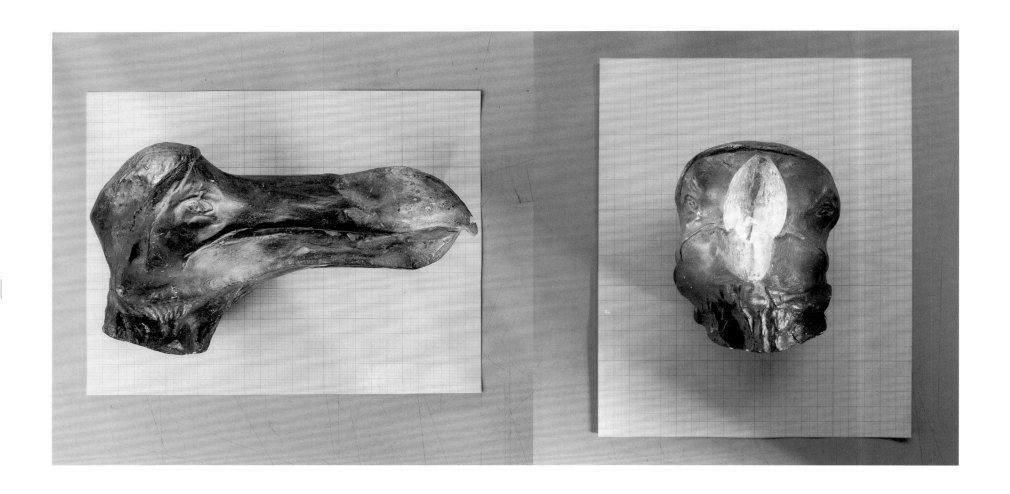

Natural History Museum, London

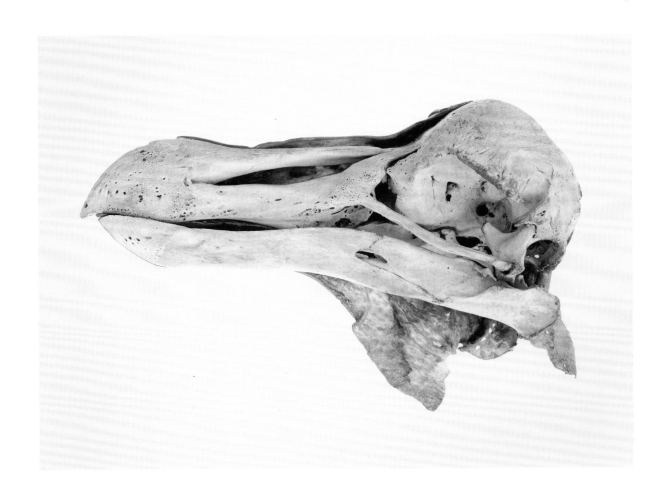

Dodo head. Oxford University Natural History Museum

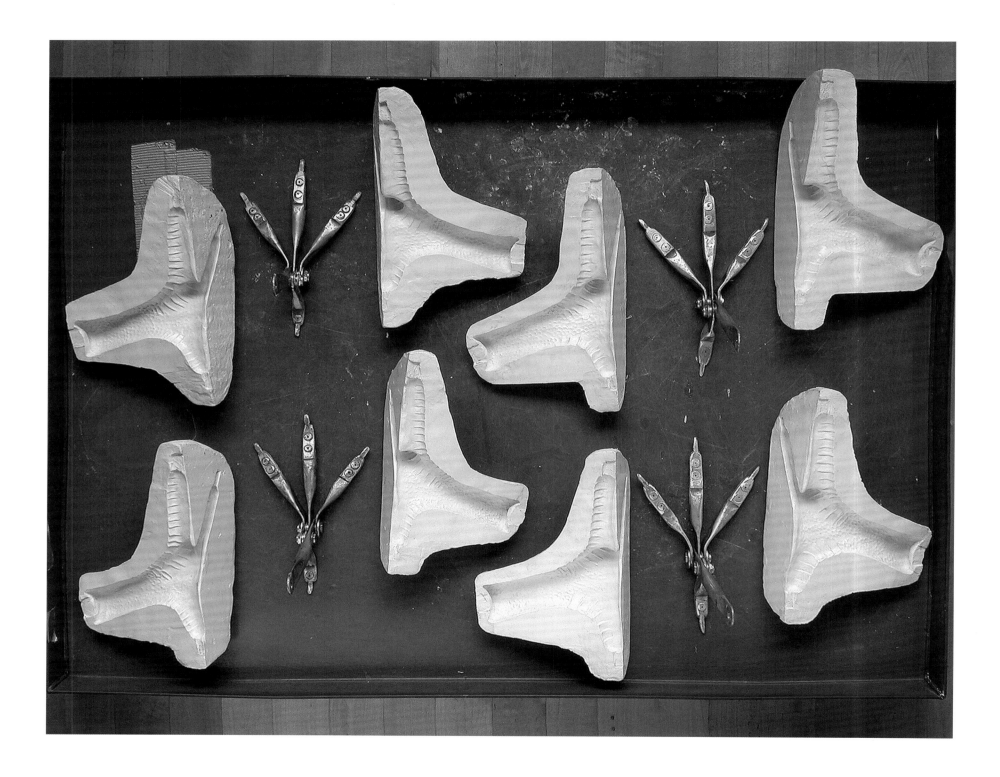

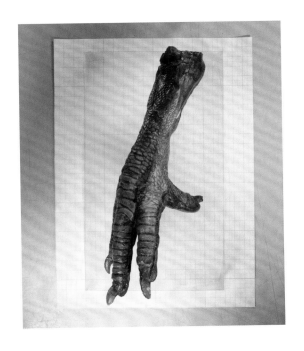

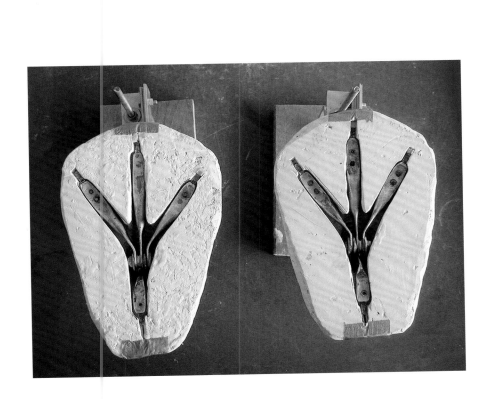

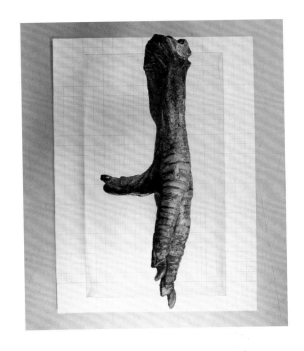

To create plumage for the reconstructions I needed to find the right kind of feathers for an appropriately down-like texture. To achieve the desired result, I had to avoid showing the curved tips of the feathers. The colour of this feather material had to be white in order to be able to dye them. After some research I found out that swan feathers, used in a certain way, came pretty close to my idea of what Dodo plumage should look like.

Swans are a protected species in most parts of the world, and as a result any that have been found dead will usually end up in a natural history museum to be mounted or incinerated. The skin collections in most museums are full of such commonplace specimens as mute swans, so most of the time the museums have to dispose of them. Through the Helsinki Natural History Museum I obtained one swan ready skinned, and another in an almost complete state with just the head missing. Both swans had died accidentally, flying into power lines, and I promptly stored these unfortunate creatures in my freezer, which was by now getting alarmingly full.

To reconstruct the wings I used goose wings, which I modified to fit the intended scale and form. I contacted a goose farmer, who coincidentally had had a fox break into his farm and kill several young geese the night before I contacted him. He gave me those geese, as they were unsuitable for human consumption. They arrived in a cardboard box at the bus station, and were full of tooth marks. They went straight into my girlfriend's freezer, as mine was already full of swans. I located material for reconstructing the Dodo's tail feathers from a suspicious sounding ostrich farmer. Even in Finland there are ostrich farms — they don't seem to mind the snow!

To stop the decomposition of the skins and feathers the materials went through a complicated taxidermy process. The skins were cleaned and treated, both mechanically and using several different taxidermy chemicals. This was a pretty unpleasant process, even though skinning the birds provided a valuable lesson about their anatomy. As a result of this chemical tanning and leatherizing process, all the proteins and organic material were turned into stable fibre. Processing all the organic material thoroughly was especially important because of the hot and humid working conditions on Mauritius. Working on the island outback is demanding enough without having to fend off swarms of flies trying to lay their eggs on the unsuspecting Dodo models.

After the taxidermy the skins, wings and tails were ready to be dyed to match the desired colours. The surprising result of dying white swan feathers with grey or grey/brown dyes is that the end result has grey tones ranging from almost black to very light grey. This kind of material could not be better for reconstructing Dodo feathers. When the results had matched the desired colours I let the skins dry. The wings and the tail feathers went through a similar process using yellow/grey dyes. The wings were dyed in two parts, as the part closer to the body seems to be almost the same colour as the plumage, whereas the rest of the wing is supposed to be light muted yellow.

To construct the plumage for the reconstructions, the feathers from the swan skins were pulled out and piled in different categories according to their colour and size. Feathers were glued on to the reconstructions one by one using a heavy duty glue, and the gaps were filled with down of a matching colour. This part of the job required endless patience — it was like putting together a giant puzzle. The structure of the bird plumage followed a simple rule — all the feathers must point away from the head to make it possible to have a slick and aerodynamic structure to enable flight, which of course is not really required for flightless birds.

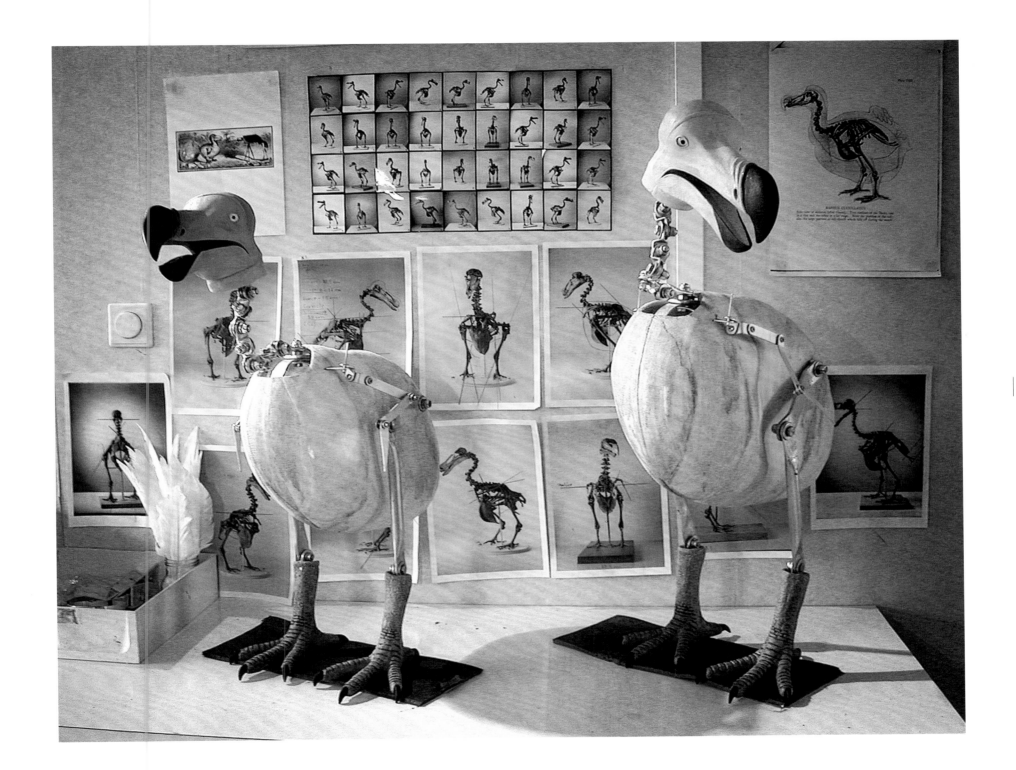

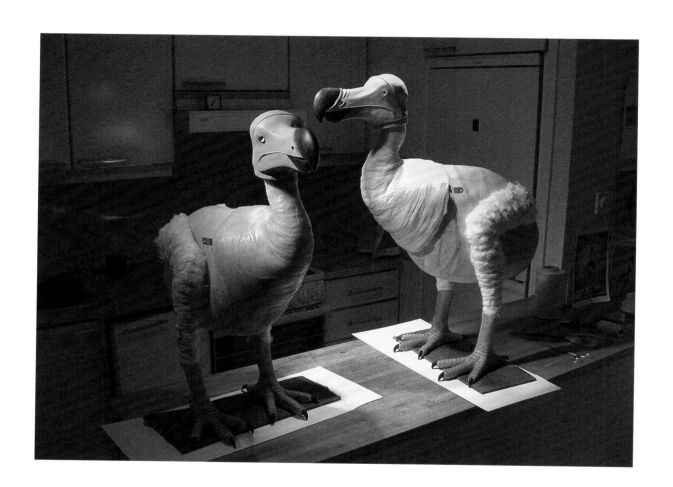

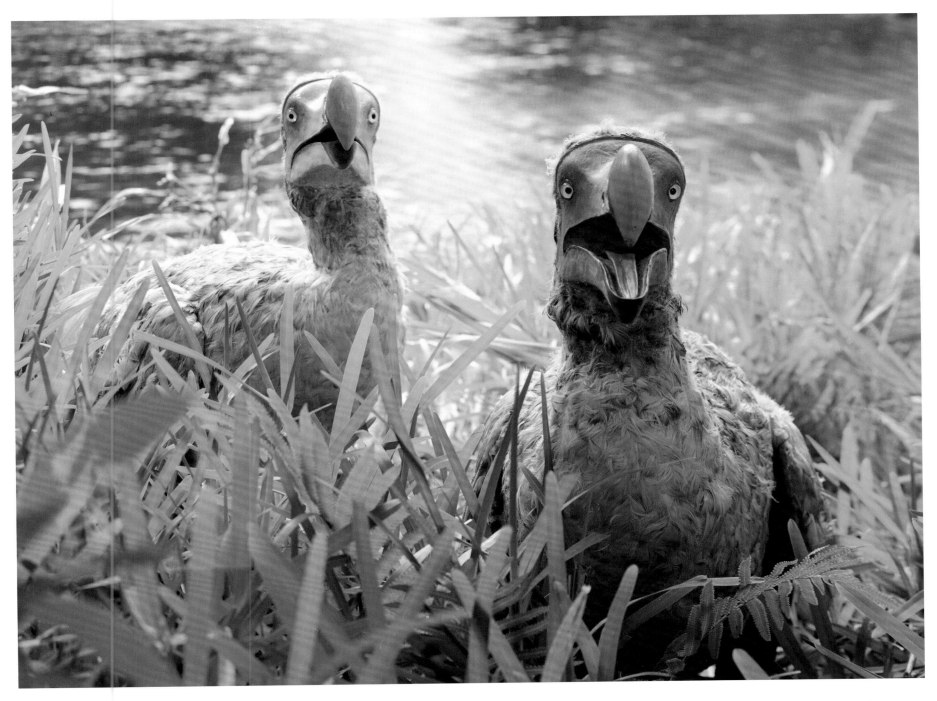

Riviere des Anguilles #7, Mauritius, 2002

THE LOST LANDSCAPE OF THE 17TH CENTURY PARADISE ISLAND

My final goal was to see these meticulously created reconstructions in their original habitat of Mauritius Island. To be able to work in exactly the same location where Dodos had existed was essential for the project. The aim was to find locations that would be as similar as possible to how they were in the early 17th century, before human presence was established on the island. I used two different approaches to construct these images — Mauritius Island as it was hundreds of years ago, before the first settlers arrival, and the moment of the Dodos' first encounters with people.

Despite its location in the middle of the Indian Ocean, the population of Mauritius is amazingly dense with over 1.2 million people — making it one of the most heavily populated areas in the world. Mauritius is part of a small group of islands called the Mascarene Islands, in which the other two main islands are Reunion and Rodrigues. Rodrigues was inhabited by a very close relative of the Dodo, the Solitaire, which shared its fate by also becoming extinct at around the same time.

Mauritius has a long history of invasion. The first European explorers who visited the island in 1507, the Portuguese, never established a permanent base. Those who followed — the Dutch, the French and the British — exploited the island's rich natural resources to their fullest extent. The island was occupied by the Dutch from 1598-1710. The French took over in 1715, but were forced to accede to the British army after a short sea battle in 1814. The island became independent in 1968, but the cultural influence and heritage from the former mother country of France remains strong, and the most commonly used language is French. However, the official language is English. The majority of the population is of Indian origin, while the remainder is Creole (descendants of African slaves) French and British origin.

Mauritius has a relatively safe and peaceful reputation, and it is rare that visitors get into trouble with the local people. Mostly people are very friendly, but there are places on the island that are not safe to wander around alone. I never had any problem with the local residents — a foreign visitor wandering about the island with two Dodos in his backpack seemed to be a tolerable phenomenon. Of course, my models attracted attention, generally in the form of a wide smile. One problem that restricts movement around the island is the incredible number of fenced off private areas — many of which are reserved for 'hunting' deer that have been introduced from Sumatra. There is also an obvious tension between the majority of the population and the descendants of the former colonial masters, who own practically everything on the island, but form only two to three percent of the population.

Mauritius is exceptionally free of venomous creatures. There are no poisonous snakes, scorpions or spiders. The only potential health hazard is malaria, which is extremely rare, or getting sunburnt, or suffering from a nasty hangover after drinking too much of the excellent local rum. However, there are an endless variety of poisonous creatures in the sea such as the stone fish, which is the most venomous in the world. It is said that if you step on a stone fish you usually die instantly due to the very concentrated nerve toxins in its fins. Better to wear shoes when going swimming! There is also an incredible number of skittish stray dogs.

Before human settlers arrived on the island, Mauritius was completely covered by dense tropical forest. Now only one percent of the original forest is left, and only a fraction of these forest areas are anywhere close to what they used to be, due to the uncontrolled spread of foreign plants and trees. Sugar cane fields, the most important part of the economy of Mauritius Island, cover seventy percent of the island. The North part of the island is almost all developed — cities and suburban areas. The 'original' Mauritius Island landscape is just as extinct as the Dodo.

Le Gris Gris #2, Mauritius, 2001

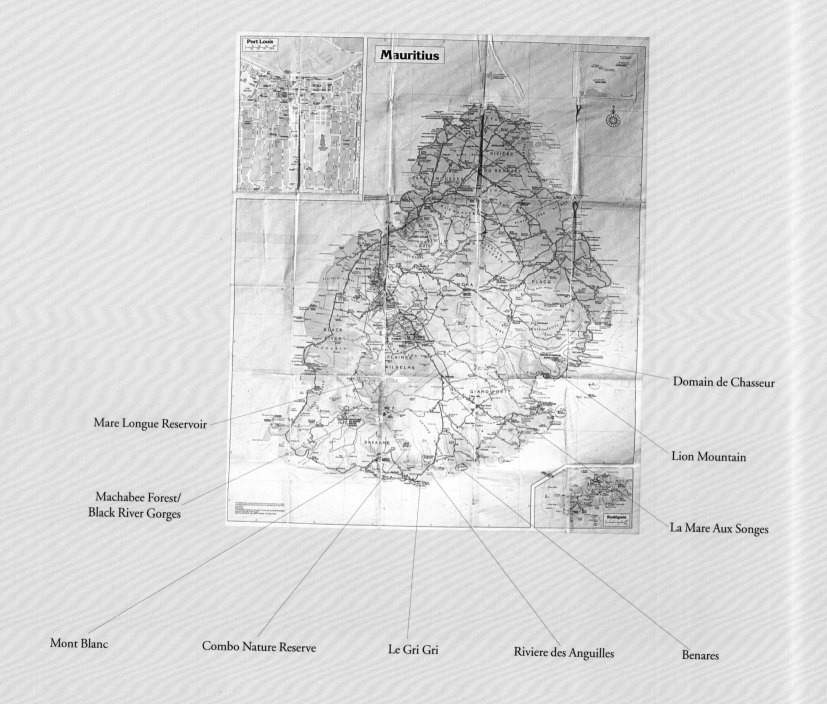

Mauritius

Port Louis

Rodrigues

Domain de Chasseur

Lion Mountain

La Mare Aux Songes

Mare Longue Reservoir

Machabee Forest/
Black River Gorges

Mont Blanc

Combo Nature Reserve

Le Gri Gri

Riviere des Anguilles

Benares

Working with the Dodo Reconstructions in the Landscape

It was possible to find locations in the more remote parts of the island that had the potential to recreate the landscape of the past. Diversity in the landscape is very typical of Mauritius.

Riviere des Anguilles is a small river in the middle of the sugar cane fields on the south coast. The river runs at the foot of a 15 metre deep canyon and is very inaccessible, which is probably why it is still relatively undeveloped. The canyon is, however, filled with trash and junk and is probably used as a dump by the local population. Once covered by dense palm tree forest this was probably one of the typical habitats for Dodos.

Many native trees and other plants in the remaining forest areas are quickly disappearing. The biggest nature preservation area on the island still has some tiny areas of forest left which have native trees. These areas are surrounded by fences so that animals, such as deer and wild pigs, will not spread the seeds of non-native plants. This is a hopeless attempt, as birds and monkeys have no trouble crossing the fences. In some locations, volunteer naturalists are removing any non-native plants they can find in order to momentarily return some remote corner of the island to its more original state.

Domain du Chasseur is a nature preservation area in the southwest of the island. The main function of this fenced area is to sustain a deer population for sports hunting. Ironically, it is also the only place on the island to have a small sample of the original palm tree forest that used to cover all the coastal areas. You have to buy a ticket to visit this area.

Most of the coast line is surrounded by a protective coral reef. However, generally it is a developed city or suburban landscape. Some parts of the south have large gaps in the reef, making these areas unsuitable for swimming because of the sharks and very strong undercurrents. These desolate locations are probably reasonably close to what they used to look like centuries ago.

Working in the field on Mauritius, carrying around camera gear and a large backpack with two neatly folded, packed up life-size Dodo reconstructions was strange but rewarding. Finding usable locations was difficult, and the only realistic approach was to travel as much as possible to find locations and moments in time that would work with my ideas. The light on the island is typical hard lighting from above, due to the sun's position in relation to the equator. Morning and evening light pass by too quickly for any kind of practical picture making purposes. Depending on the time of the year there are few or no clouds at all, unless it's the monsoon season. The weather conditions often forced me to wait for long periods to make a photograph.

My pictures often contain more than one Dodo character. If there is more than one male and one female in the same picture, then the working process is very different to the traditional idea of a photograph, which is always based on one single moment before the camera. The only practical way to work with more than two Dodo characters was to shoot several sheets of 4 x 5 film of the same scene, whilst repositioning the models between exposures.

Producing one image with many Dodo characters can take several hours or even a whole day, depending on the number in the picture, the local weather and other working conditions. Each character is photographed one (or two, male and female) at a time, and the resulting images assembled later in digital post production. The intermediate stages are marked on the ground glass of the camera in order to get an adequate idea of the overall composition. The resulting image looks like one single moment, even though what the camera recorded happened over a longer period of time. Because of this open-ended working process, I am unable to see all the elements of the final image at the same time on the ground glass and the final result is always a surprise.

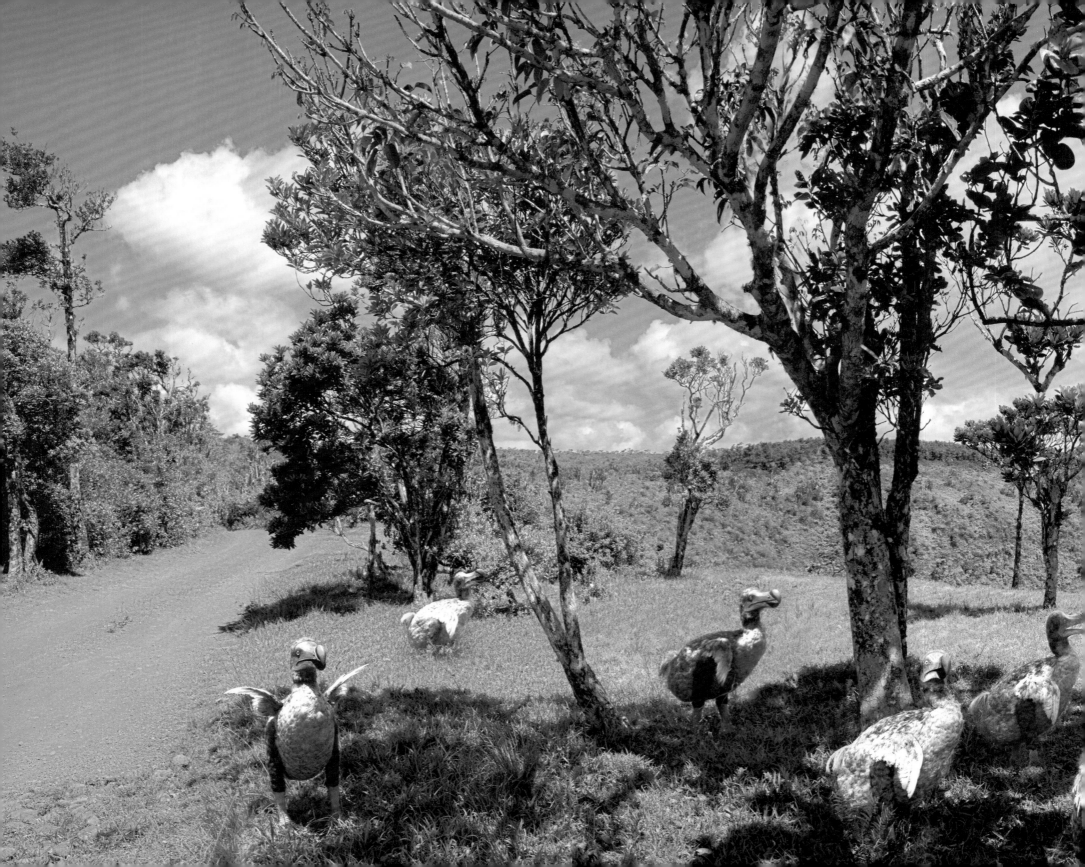

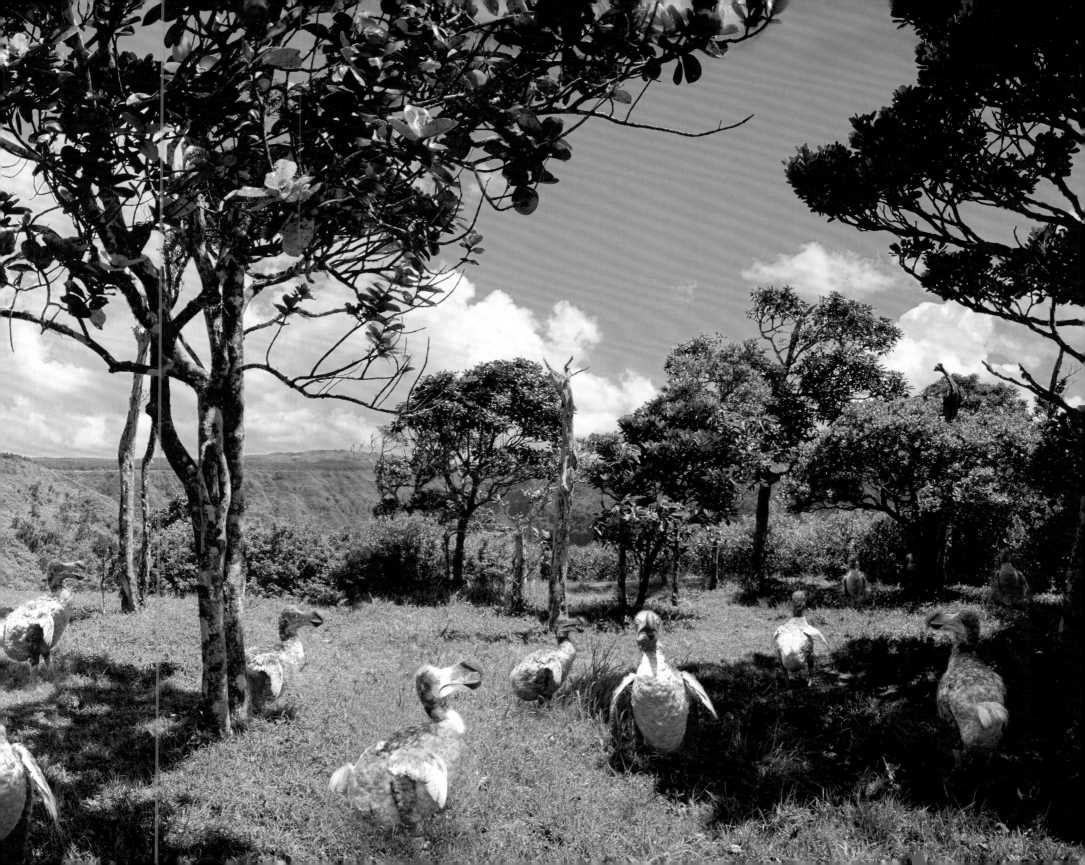

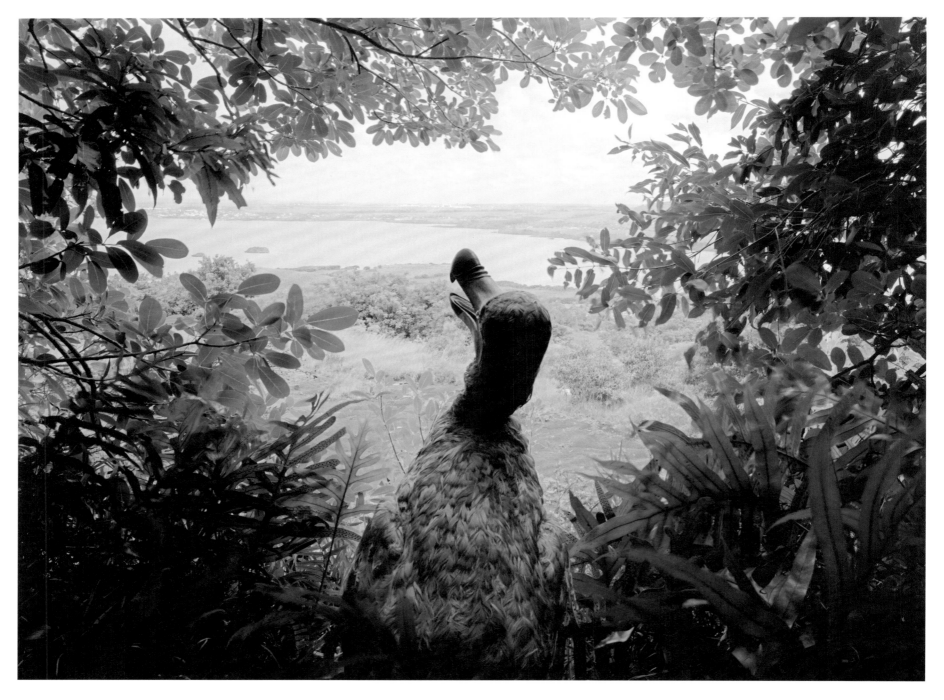

Lion Mountain #4, Mauritius, 2004

The Dodo was one of the most peculiar and fantastic creatures ever to have lived. What is left of it today? A dried head, a skeleton of a foot and a few pieces of skin in Oxford; a foot in London (maybe); a skull in Copenhagen; a beak and the skeleton of a leg in Prague; several composite fossil skeletons and boxes full of loose fossils in the museums around the world; a collection of drawings and paintings, most of which were made either from memory or by using specimens brought to Europe; a series of vague and contradictory written eyewitness descriptions. A wonderful, peculiar species – a gentle creature – has ceased to exist.

Riviere des Anguilles #2, Mauritius, 2001

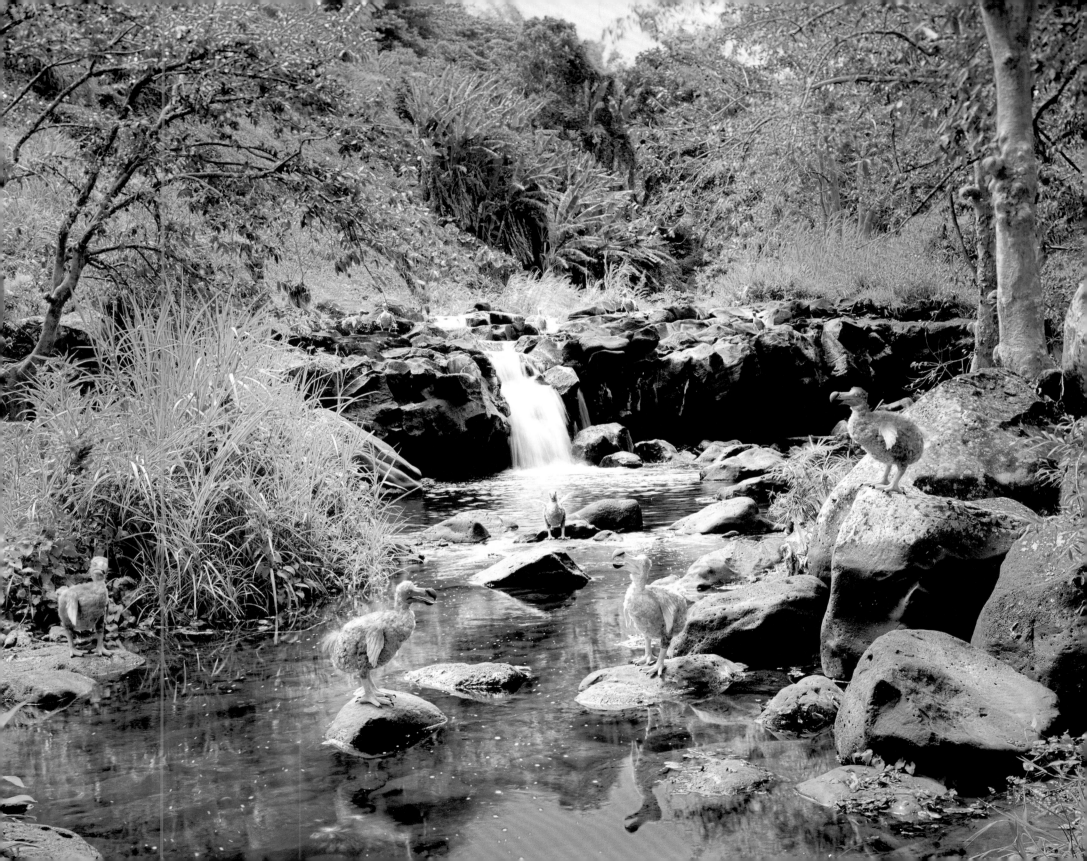

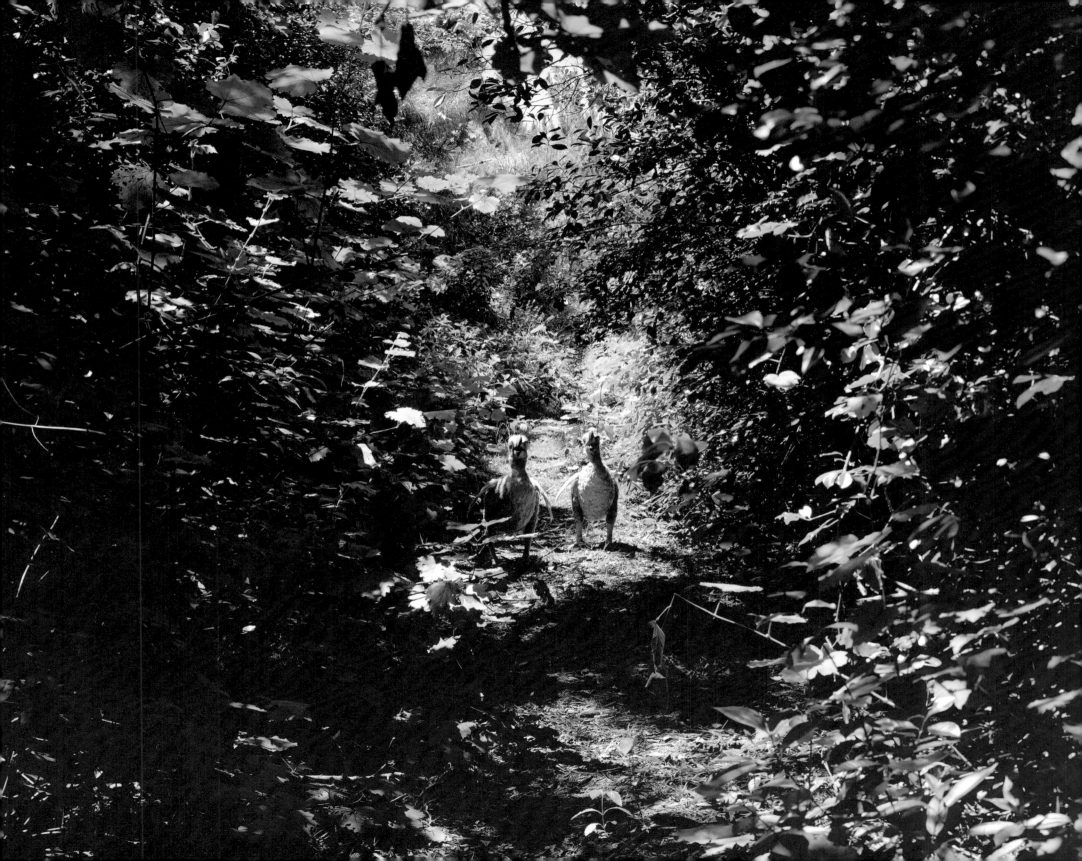

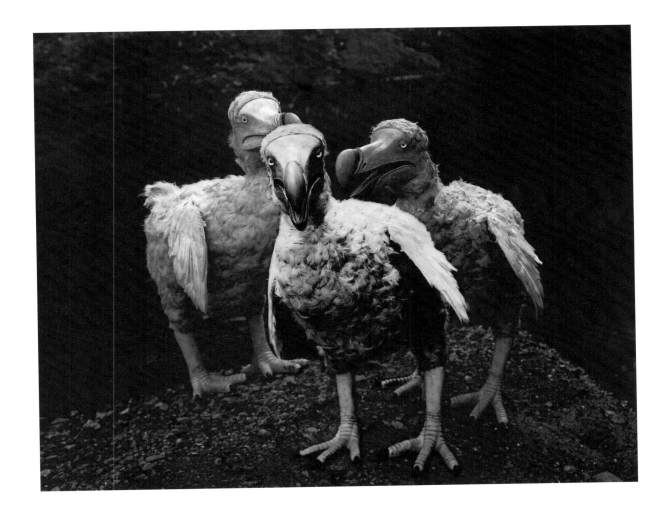

▲ Mont Blanc #2, Mauritius, 2001

◀ Macchabee Forest #1, Mauritius, 2001

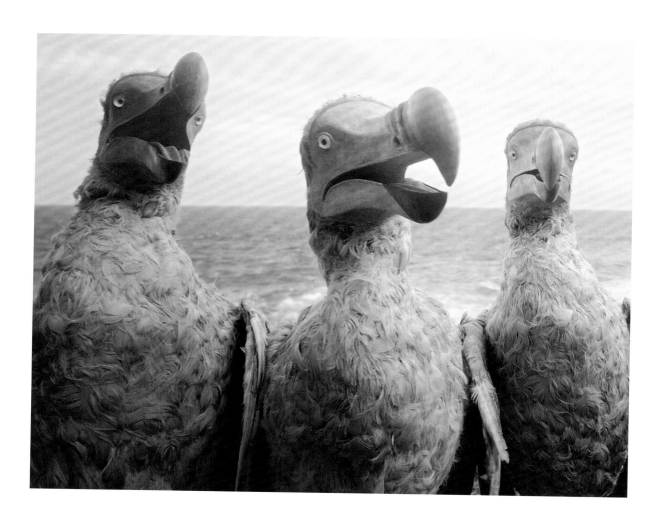

Benares #6, Mauritius, 2004

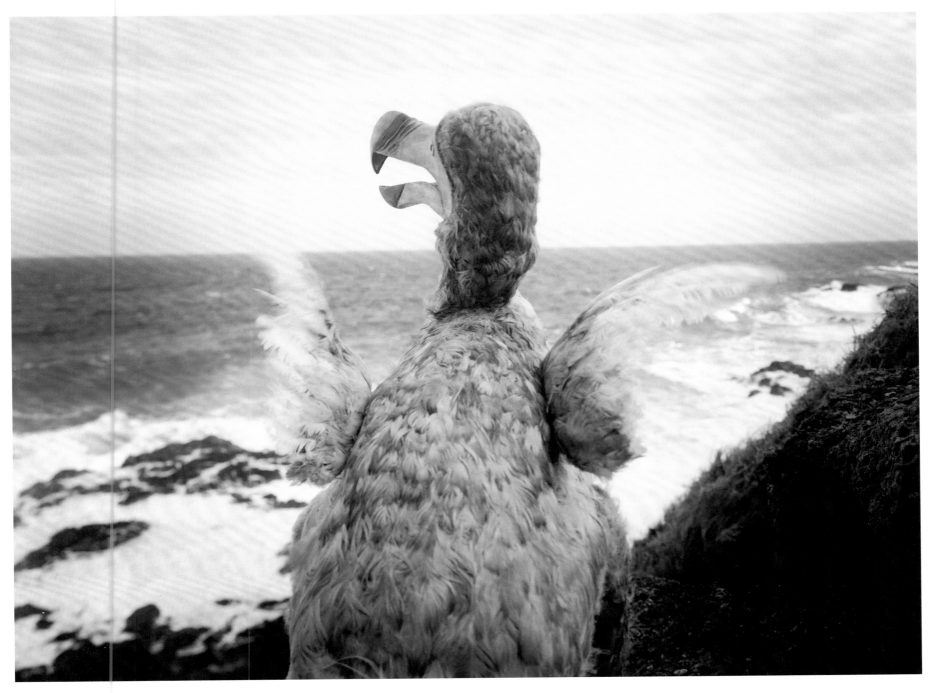

Benares #5, Mauritius, 2004

Riviere des Anguilles #6, Mauritius, 2002

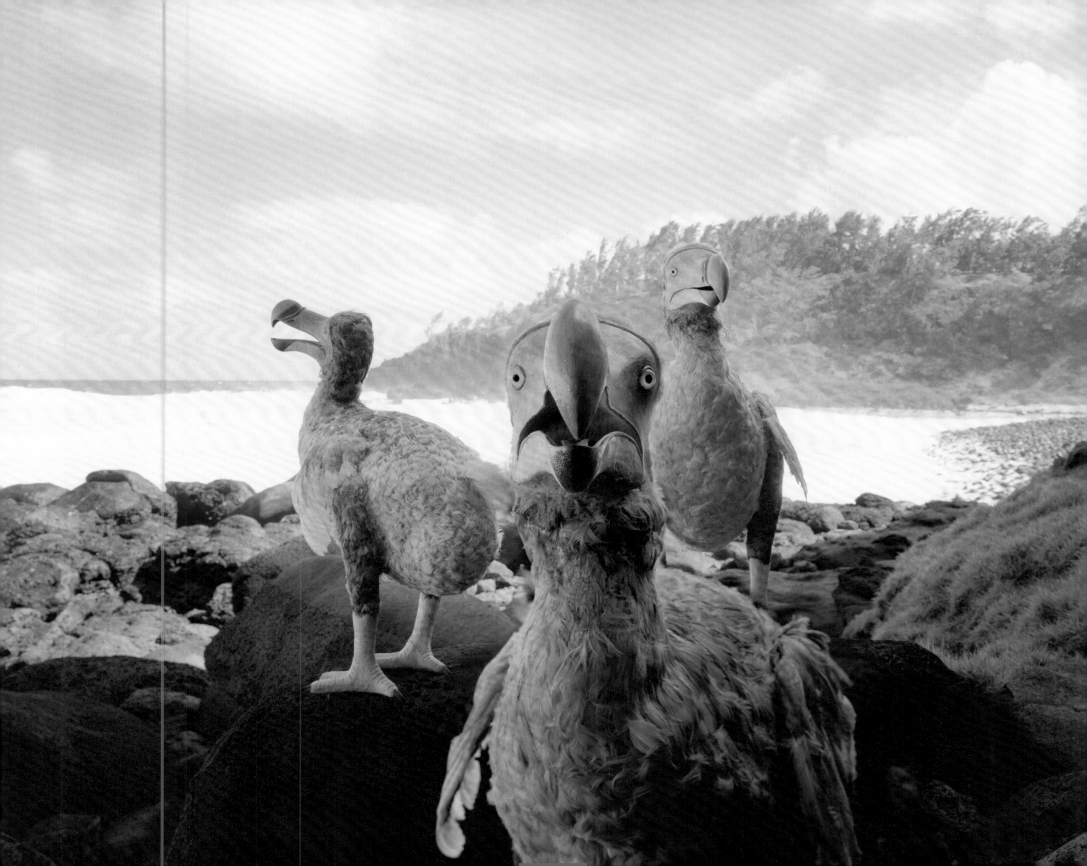

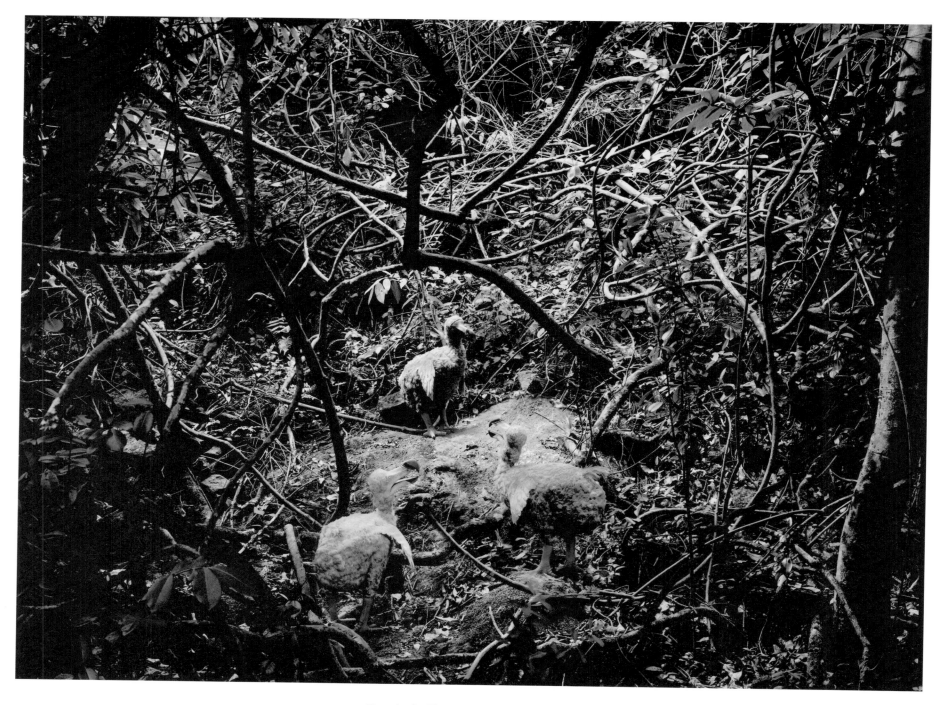

Domain du Chasseur #1, Mauritius, 2001

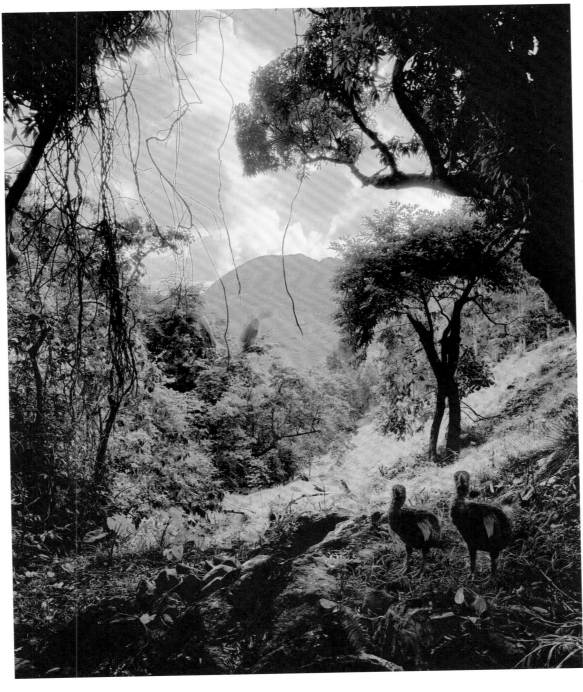

Domain du Chasseur #2, Mauritius, 2001

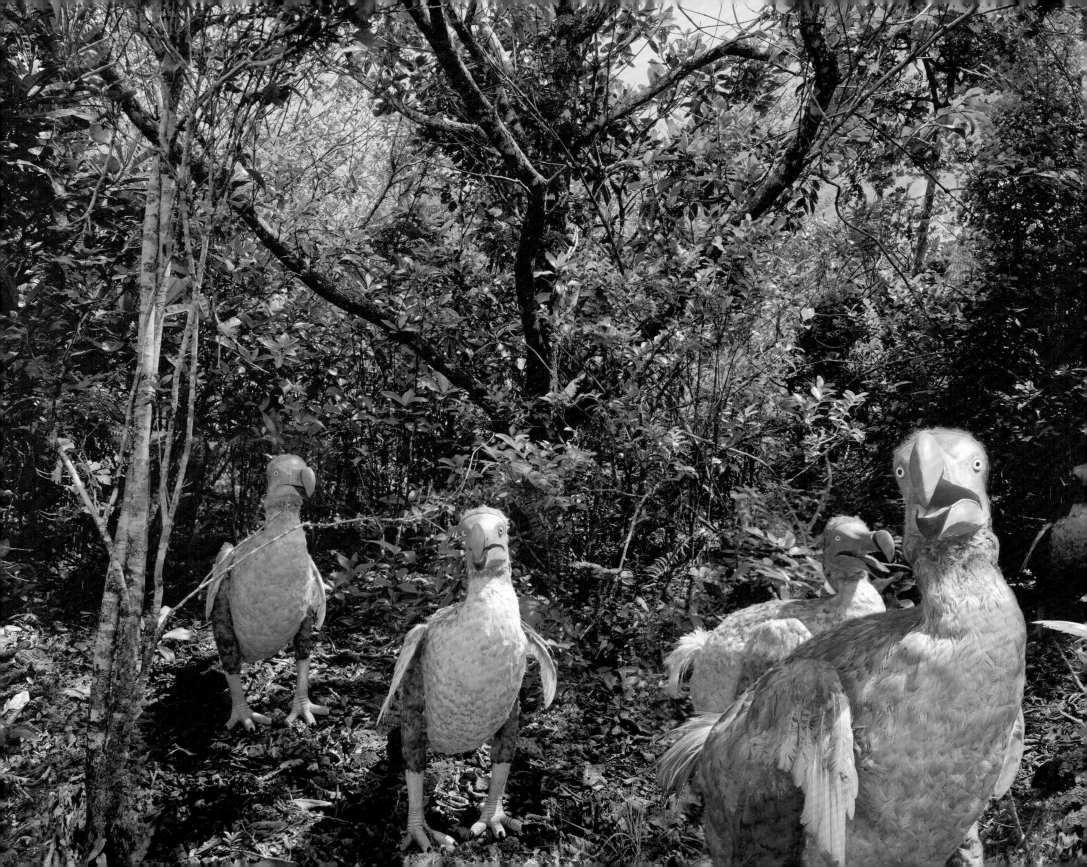

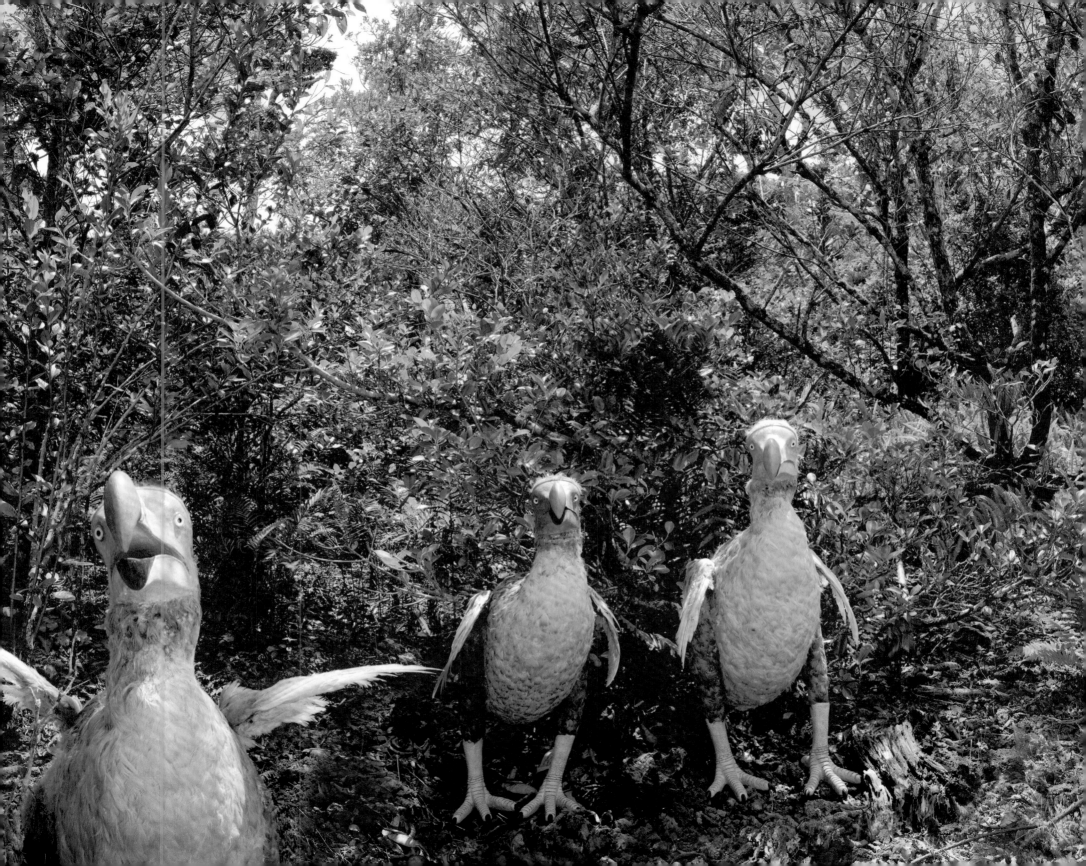

Riviere des Anguilles #7, Mauritius, 2002

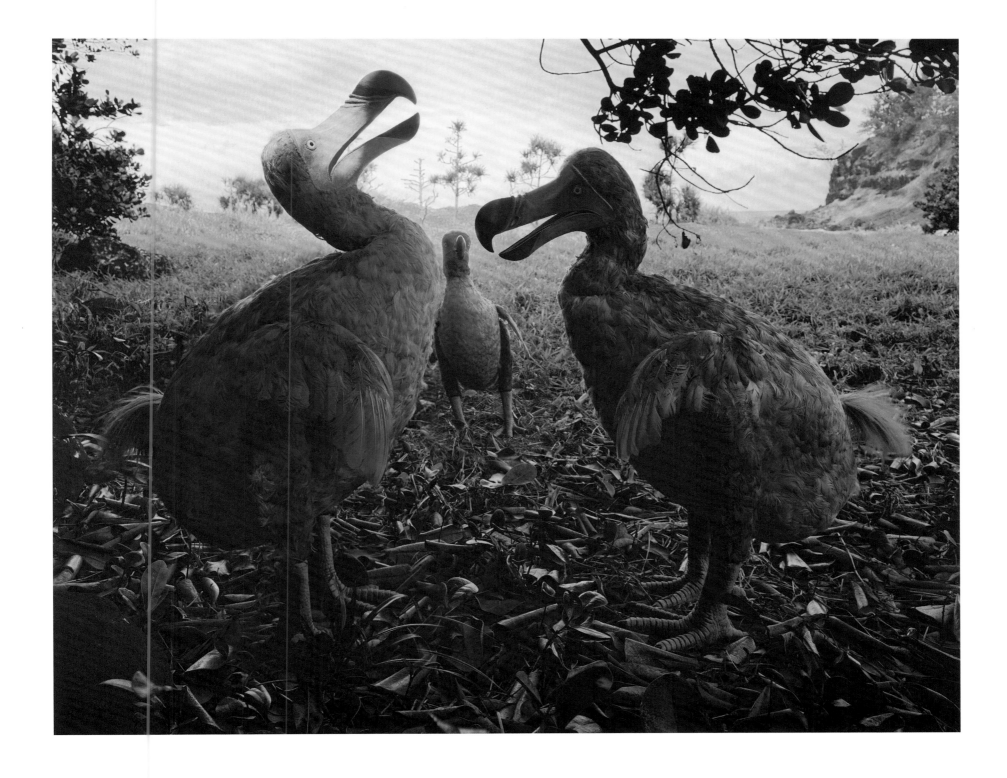

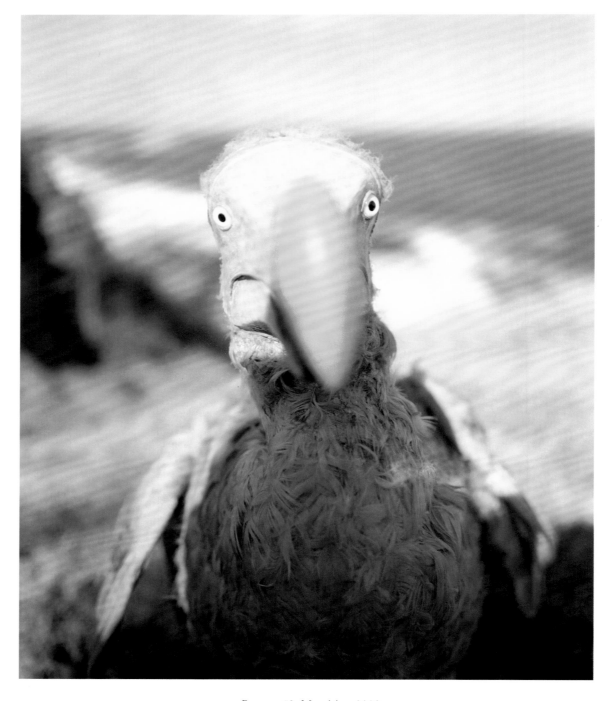

Benares #3, Mauritius, 2002

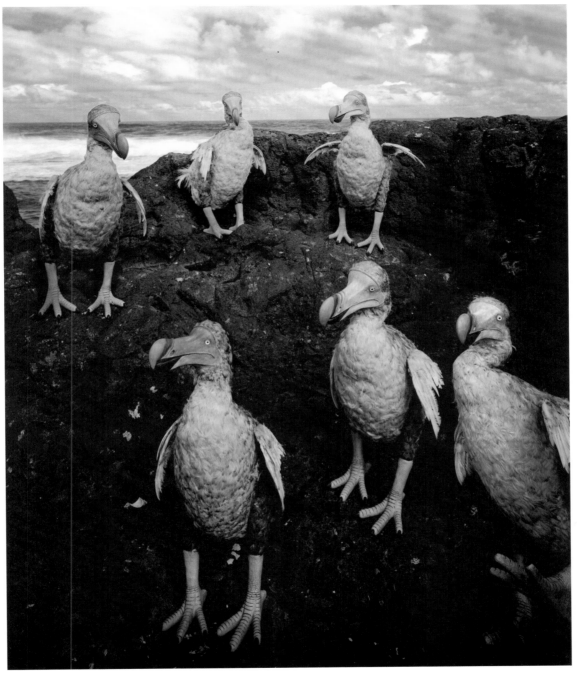

Gris Gris #4, Mauritius, 2004

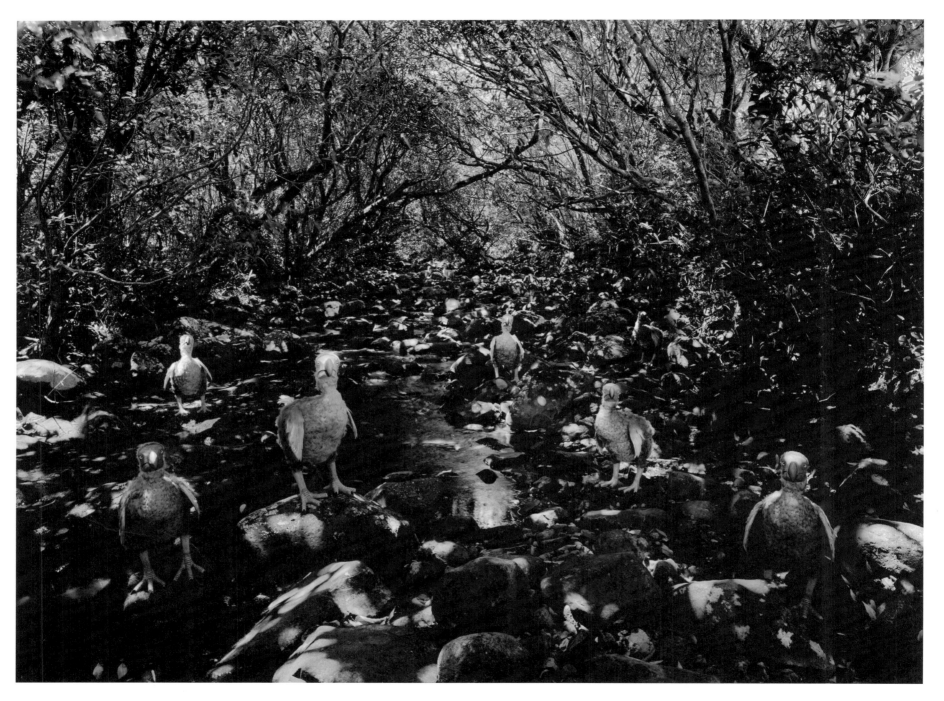

Mont Blanc #1, Mauritius, 2001

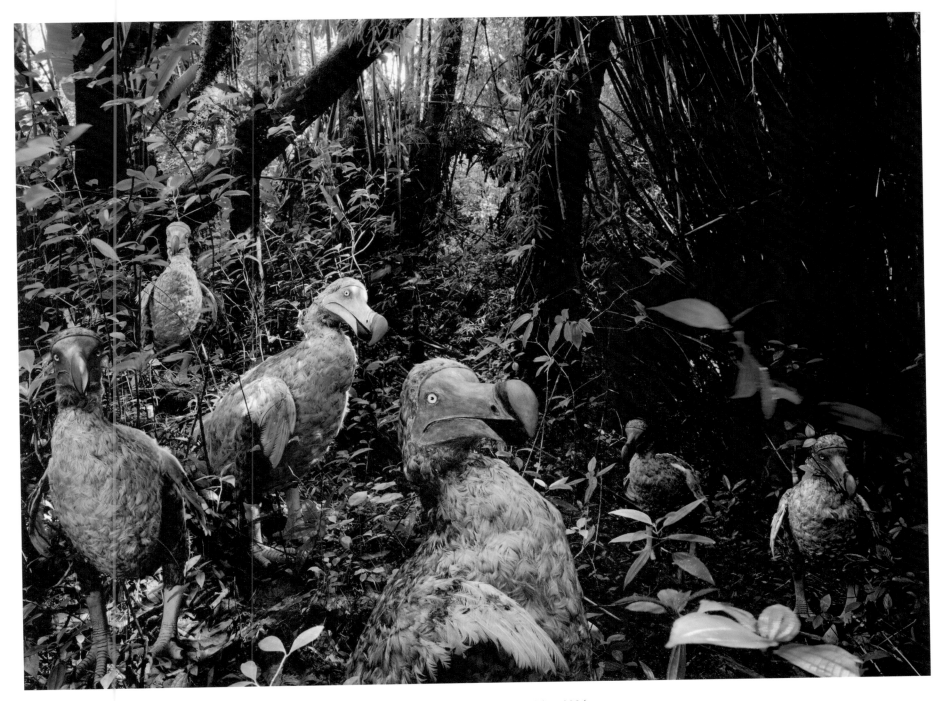

Combo Nature Reserve #5, Mauritius, 2004

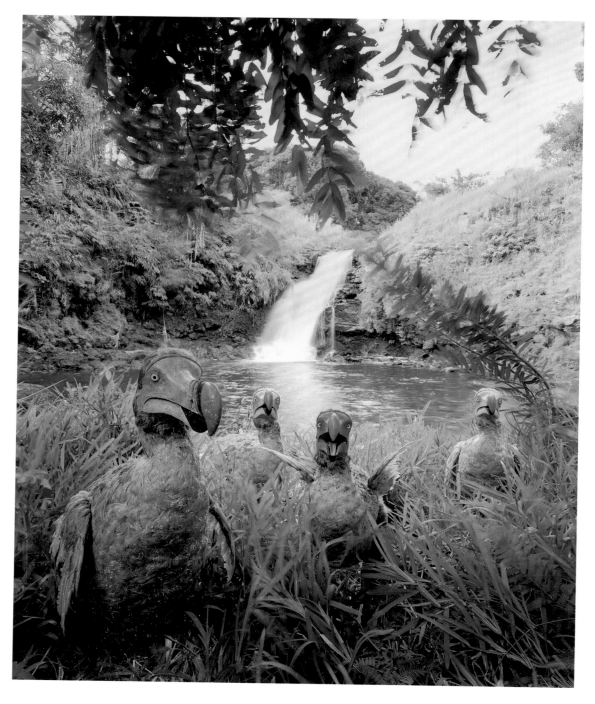

Riviere des Anguilles #4, Mauritius, 2002

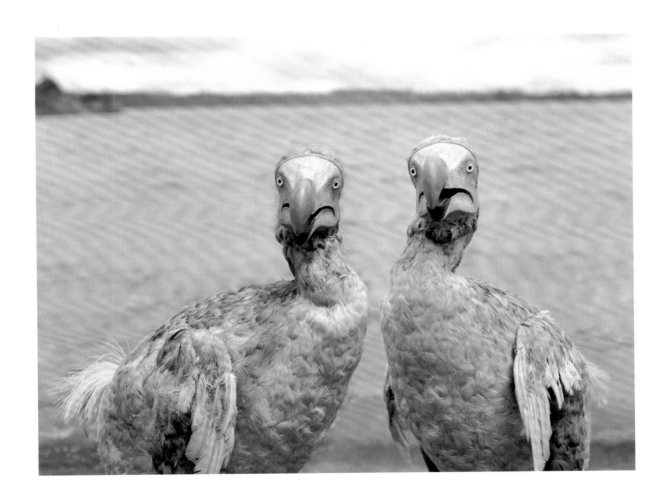

Mare Longue Reservoir #1, Mauritius, 2002

Benares #4, Mauritius, 2004

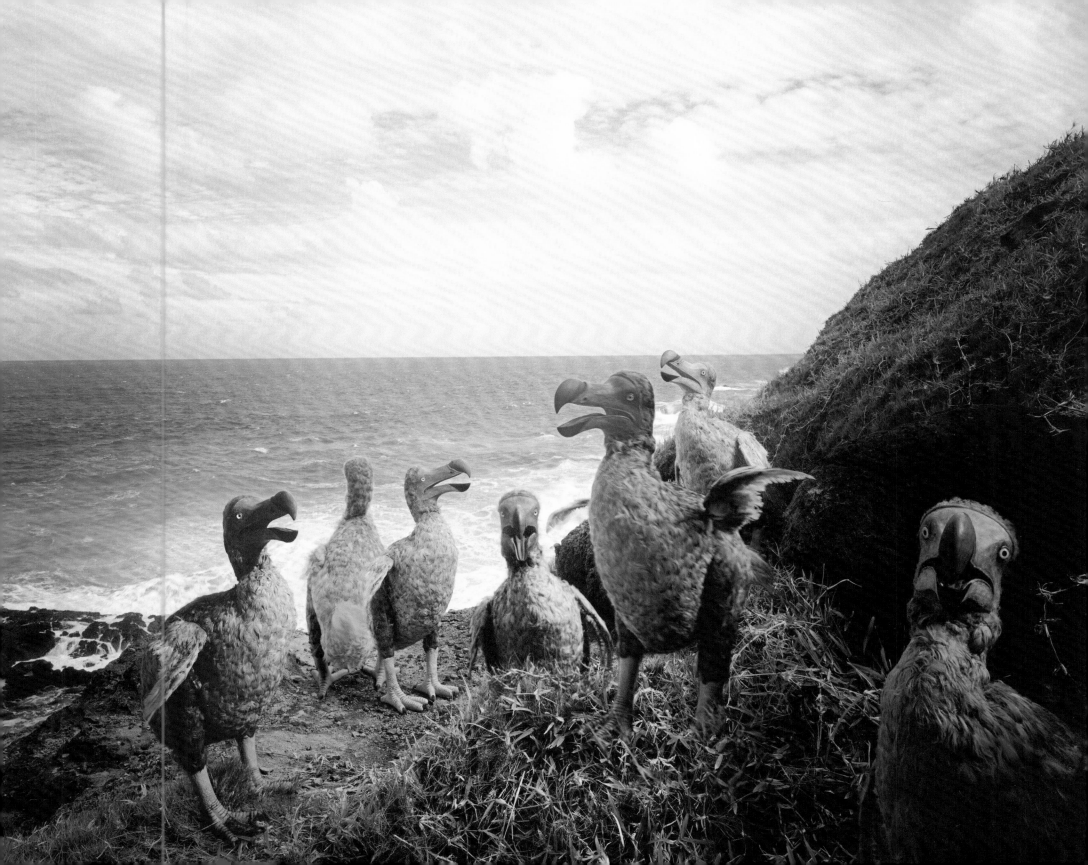

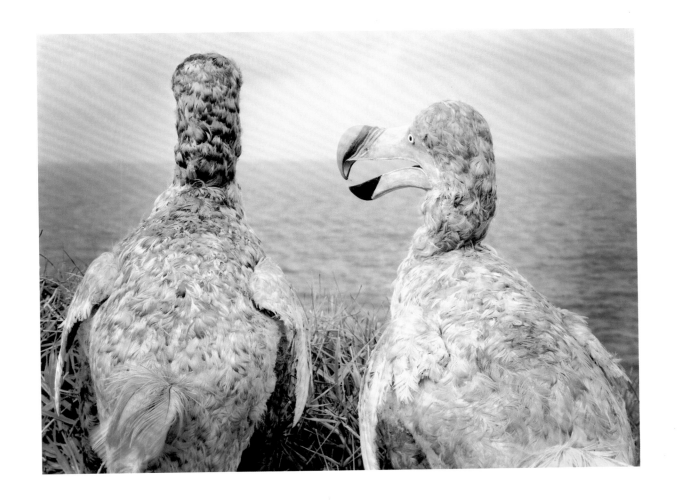

▲ Benares #8, Mauritius, 2004

◀ Lion Mountain #1, Mauritius, 2001

Gris Gris #3, Mauritius, 2004

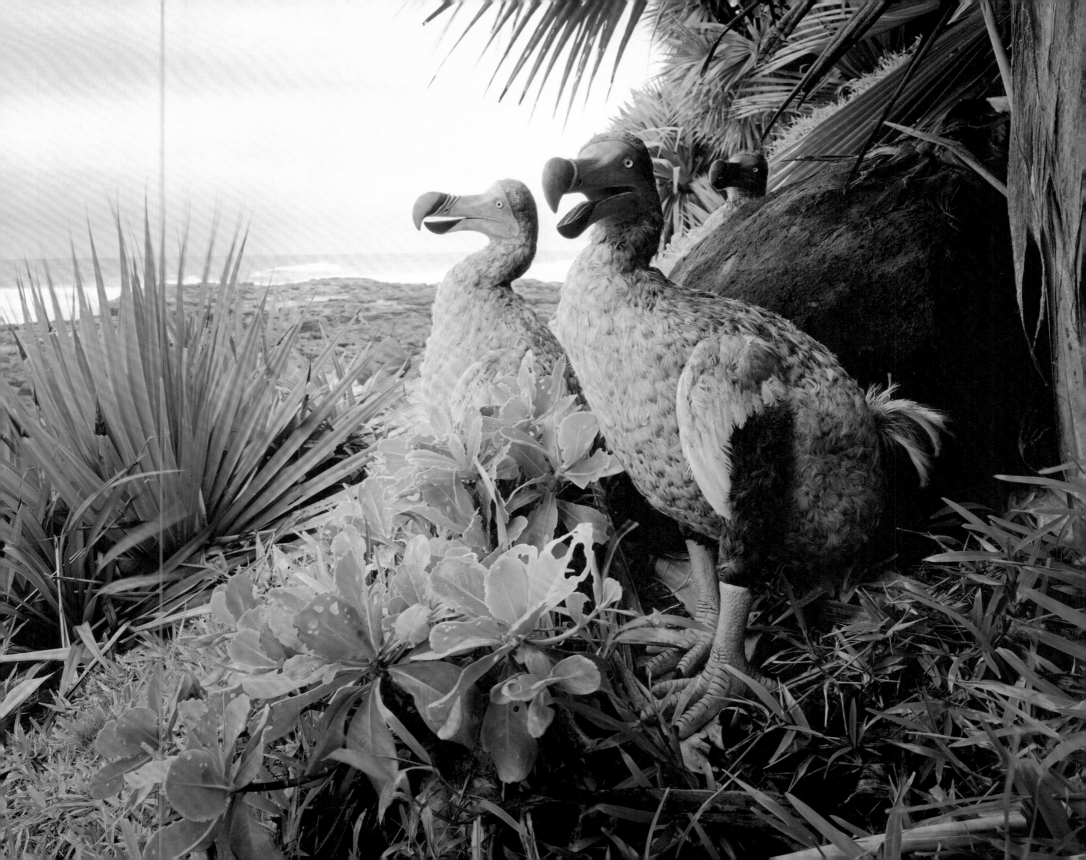

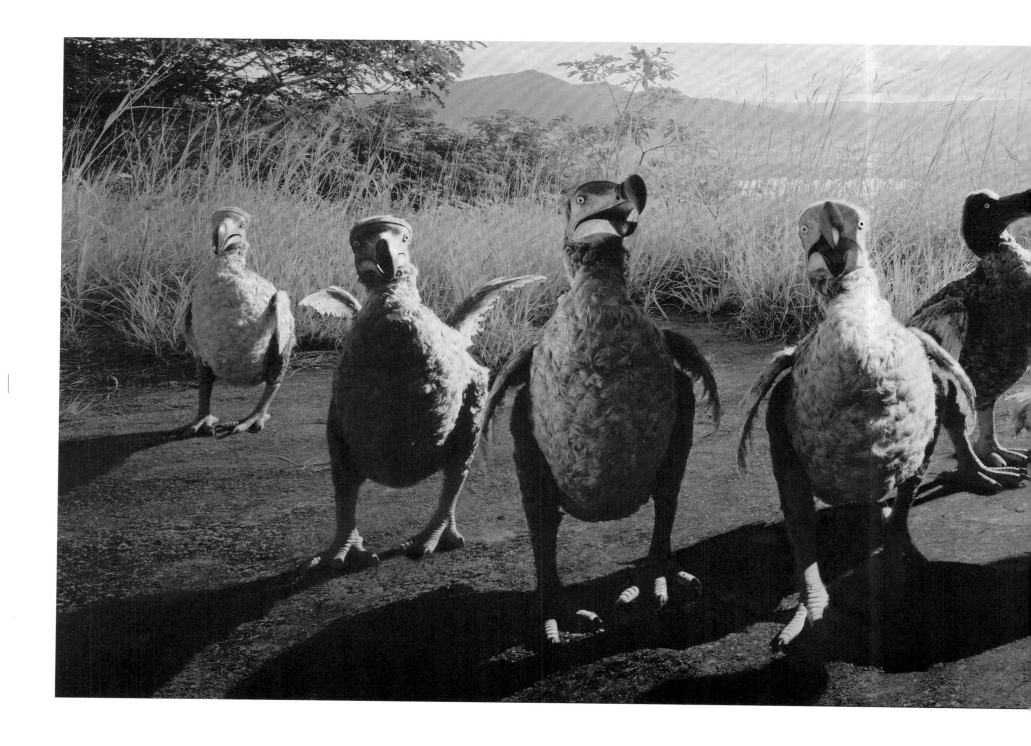

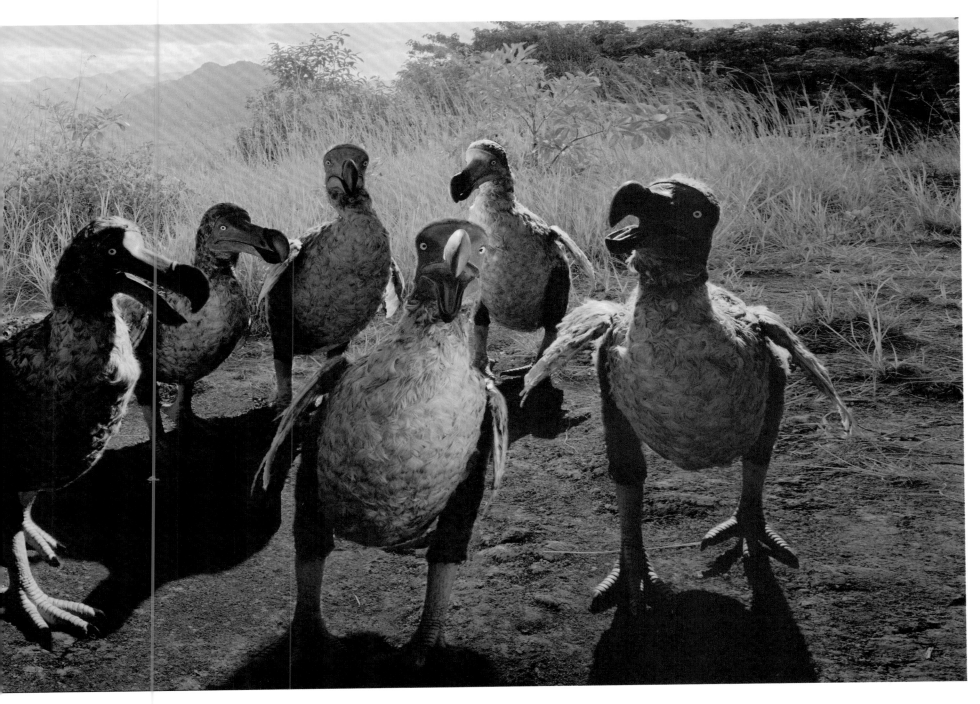

Lion Mountain #5, Mauritius, 2004

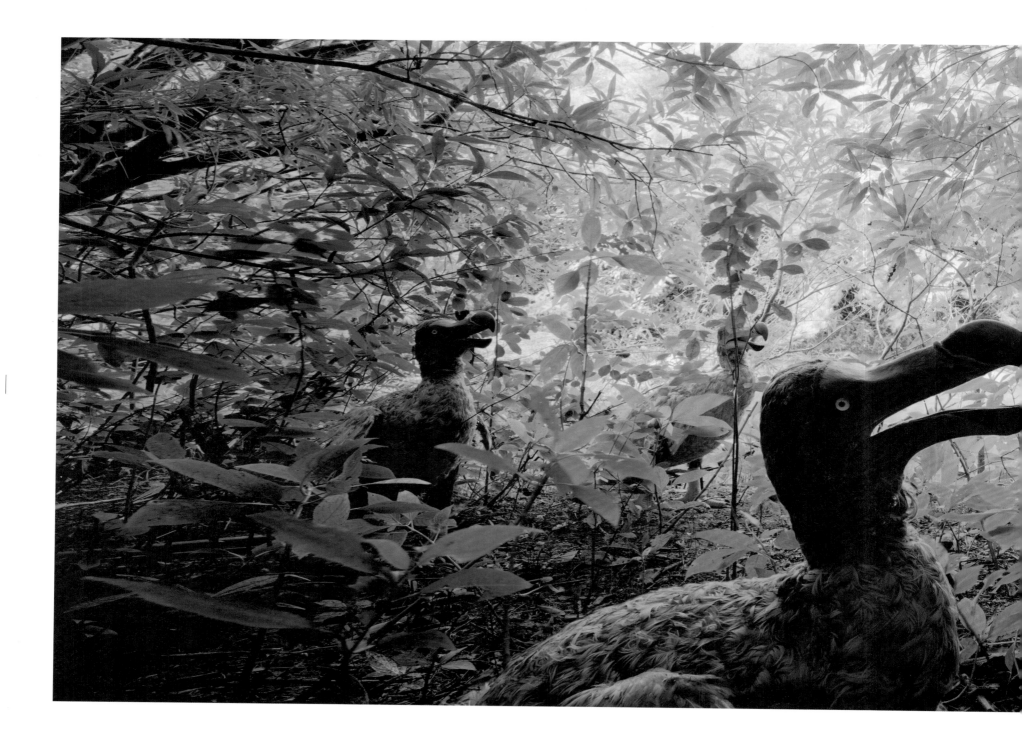

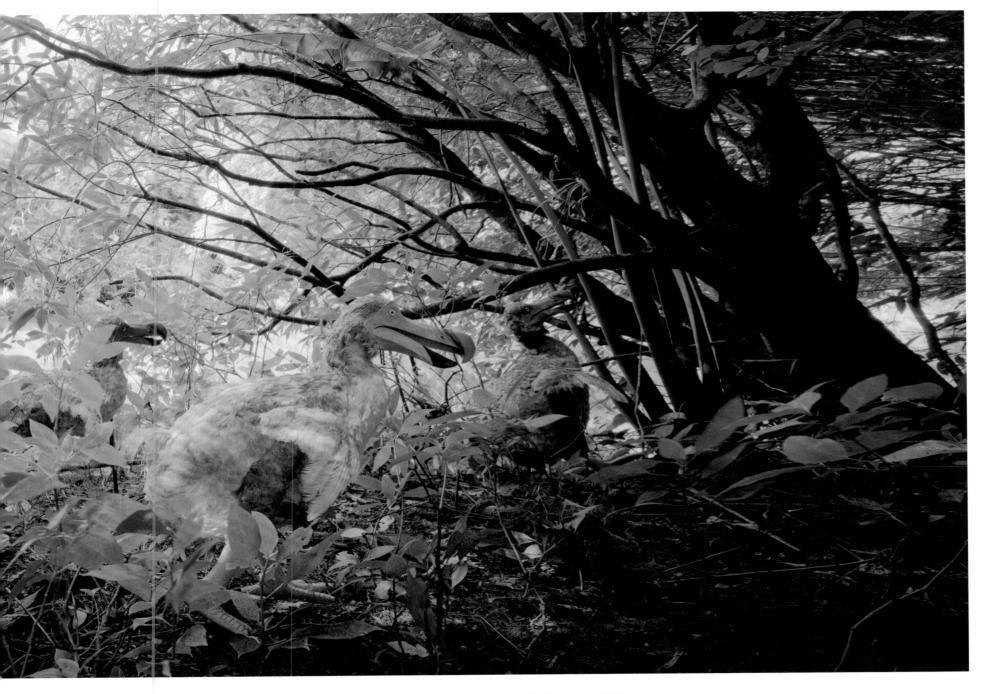

Combo Nature Reserve #6, Mauritius, 2004

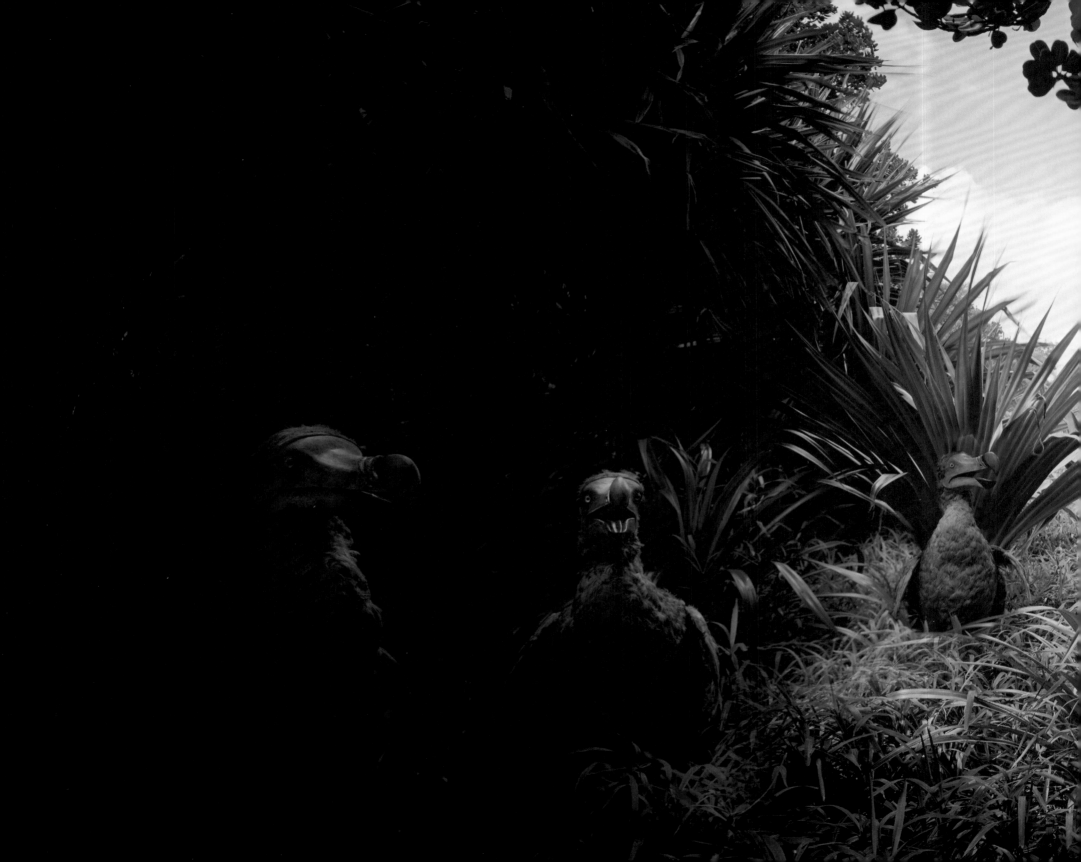

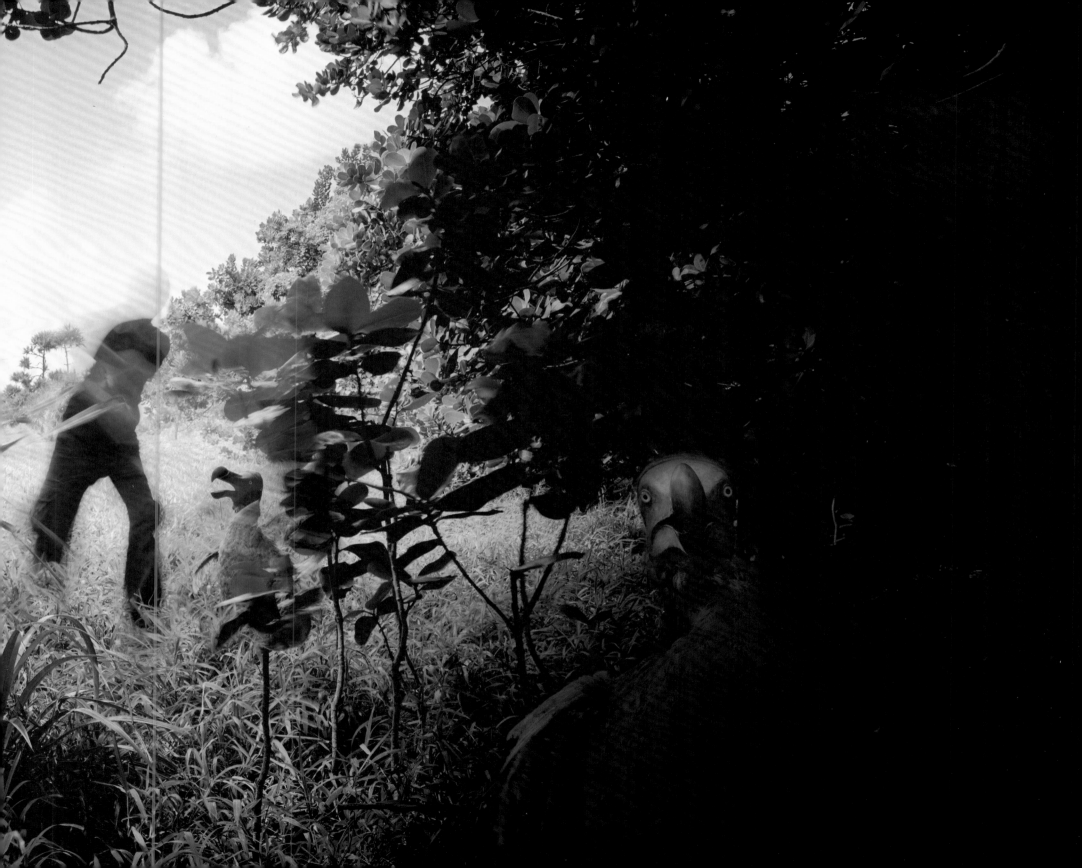

Combo Nature Reserve #3, Mauritius, 2004

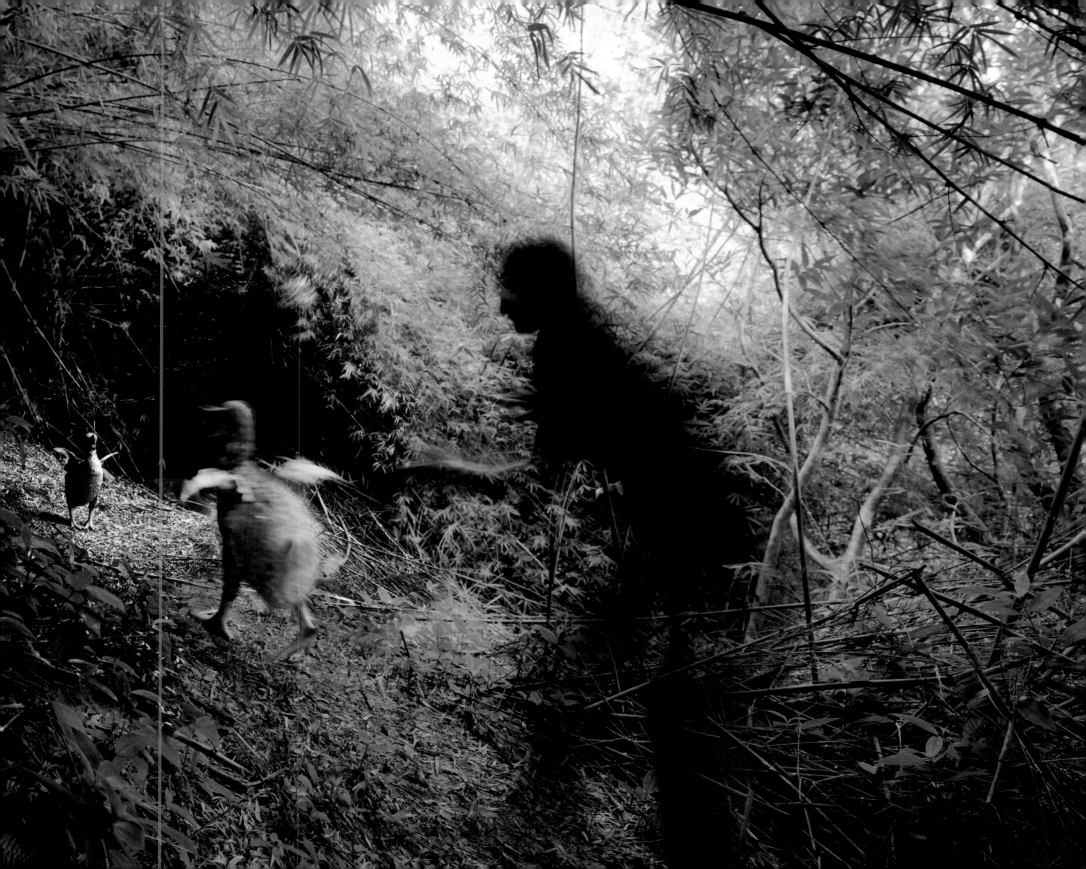

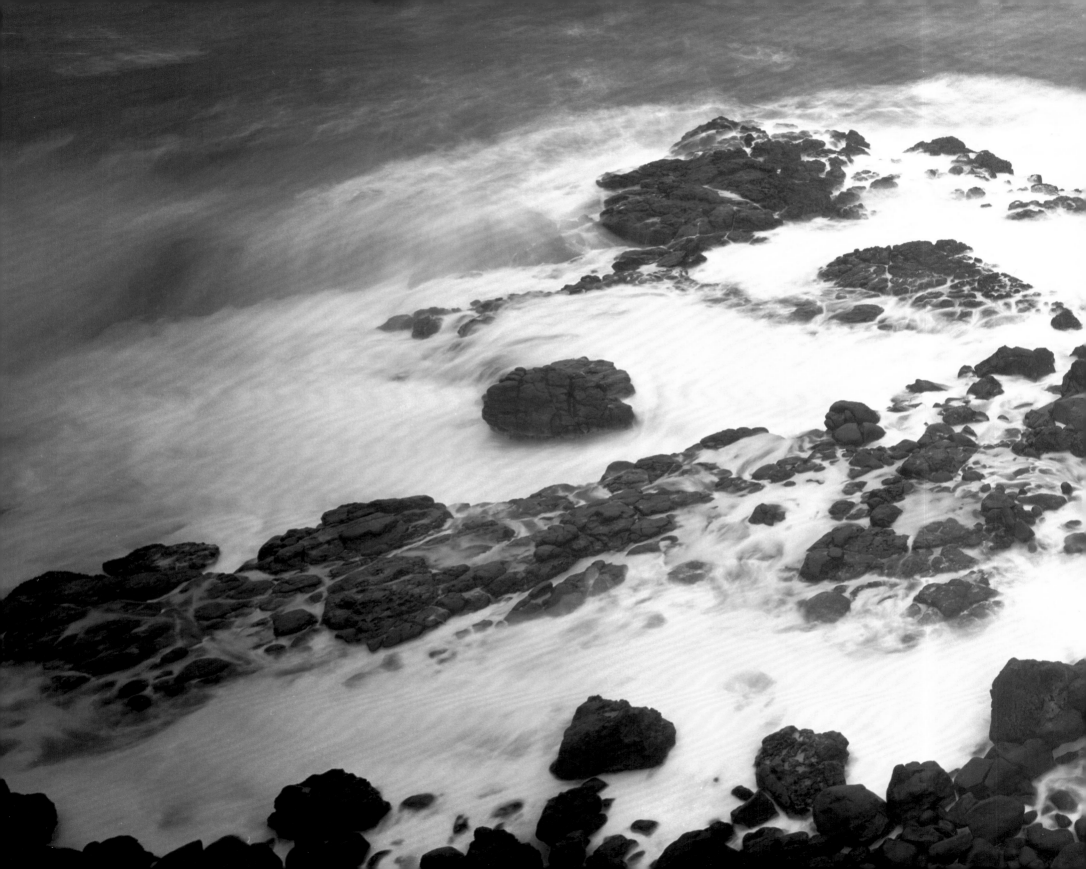

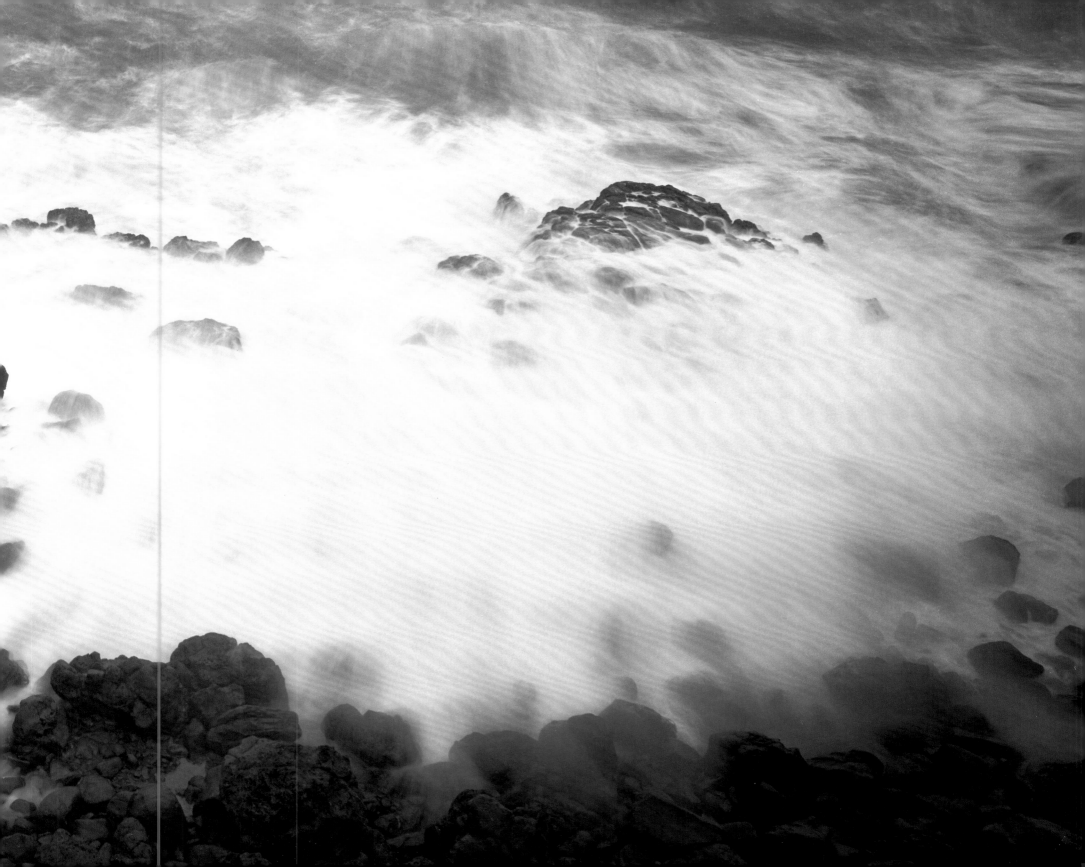

Bibliography

Adams, Douglas, and Mark Carwadine. *Last chance to see*, London: 1990.

Balouet, Jean Cristophe. *Extinct species of the world*, London: 1990.

Broderip, W.J. *On the Dodo*, annals of magazine of natural history. London: Jan 1885.

Carroll, L., *Alice's Adventures in Wonderland*, Clarendon Press, Oxford: 1865.

Cheke.A.S., 'Did the dodo do it', Animal Kingdom. Feb/March, 1984.

Cheke.A.S., *Studies of Mascarene Island Birds*, edited by A.W. Diamond, 1987.

Cooper A., 'Flight of the Dodo', Science Vol. 295, 1 March 2002.

Davies, K.C., Hull, J., *The zoological collections of the Oxford University Museum*, Oxford: 1976.

Day, D., *The doomsday book of animals, unique natural history of three hundred vanished species*, 1981.

Dahmes, S., *The Breakthrough Bird Taxidermy Manual*, 1988.

Dixon, C., *Lost and vanishing birds*, 1898.

Eeckhout, P., *Roelandt Savery, 1576-1639*, 1954.

Feduccia, A., *The origin and evolution of birds*, 1996.

Fuller, E., *Extinct birds*, London: 1987.

Fuller, E., *Dodo, A brief history*, New York: 2002.

Gerten, H., Mai, E., Schlagenhaufer, M., *Roelandt Savery in seiner Zeit*, Köln: 1985.

Greenway, J.C., *Extinct and vanishing birds of the world*, New York: 1958.

Hachisuka, M., *The Dodo and kindred birds*, London: 1953.

Halliday, T., *Vanishing birds their natural history and conservation*, London: 1978.

Janoo, Anwar, 'On a hitherto undescribed Dodo cranium, Raphus cucullatus', Bulletin du museum national d'Histoire naturelle, Paris: 1996.

Keynes, Q., 'Mauritius, Island of the Dodo', National Geographic Magazine. Jan 1956.

Kitchener, A., 'Justice at last for the Dodo', New Scientist. 28 August, 1993.

Kitchener, A., 'Expedition to Wonderland', BBC Wild Life vol.8, no.8, August 1990.

Lanteri, E., *Modelling and sculpting animals*, New York: 1985.

Livezey, B., *An ecomorphological review of the dodo Raphus cucullatus and solitaire Pezophaps solitaria flightless columbiformes of the Mascarene island*, 1993.

Maddox, J., 'Bringing the extinct Dodo back to life', Nature, Vol. 365, September 1993.

Maurel, M., *Mauritius*, Globetrotter travel guide, 1995.

NgCheong-Lum, R., *Culture shock, Mauritius*, Singapore: 1997.

Owen, R., *Memoir on the Dodo (Didus ineptus Linn)*, London: 1866.

Pinto-Correia, C., *Return of the crazy bird*, New York: 2003.

Quammen, D., *The song of the Dodo: island biogeography in an age of extinctions*, 1996.

Quikelberge, Clive, *Collections and recollections, the Durban Natural History Museum, 1887-1987*, 1987.

Silverberg, R., *The Auk, the Dodo and the Oryx, Vanished and vanishing creatures*, New York: 1967.

Smooth-on.com, *How To Make Molds & Castings (And Live To Tell About It!)*.

Spectrum Guide to Mauritius, New York: 1997.

Strickland, H.E., Melville, A.G., *The Dodo and its Kindred*, London: 1848.

Temple, Stanley, 'The Dodo haunts a forest', Animal Kingdom, Feb/March, 1983.

van Wissen, B., *Dodo, Raphus cucullatus (Didus ineptus)*, 1995.

Ziswiler, Vincent, *Der Dodo-Fantasien und Fakten zu einem verschwundenen Vogel*, Zurich: 1996.

CAPTIONS

pages 6-7: Lion Mountain #3, Mauritius, 2004

pages 72-73: Lion Mountain #2, Mauritius, 2004 (Gap in the coral reef where Dutch explorers entered the lagoon to set foot on the island 1640)

pages 78-79: Black River Gorges #1, Mauritius, 2001

pages 92-93: Black River Gorges #2, Mauritius, 2002

pages 112-113: Riviere des Anguilles #8, Mauritius, 2002

pages 116-117: Benares #10, Mauritius, 2002

Museums possessing remains of the Dodo (*Raphus cucullatus*)

Amsterdam
Zoological Museum of the University
of Amsterdam. Fairly complete skeleton.

Berlin
Humboldt University Zoological Museum.
Separate skeleton parts.

Cambridge
Cambridge University Zoological Museum.
Virtually complete skeleton reconstructed
c.1889-1892 under the direction of A.
and E. Newton. A lot of skeleton material
in the scientific collection.

Cambridge, Massachusetts
Museum of Comparative Zoology.
Two incomplete reconstructed skeletons.

Dublin
National Museum of Natural History.
Reconstructed skeleton.

Durban
Durban Museum.
Reconstructed skeleton, purchased 1919.
Origin: Mr Thirioux, Mauritius.

East London
East London Museum.
Dodo egg, authenticity not confirmed.

Edinburgh
Royal Museum of Scotland.
Incomplete reconstructed skeleton, model.

Frankfurt
Senckenberg Museum. Reconstructed skeleton.

Japan
Hachisuka Collection. Several skeleton parts.
Current location unknown.

Copenhagen
Zoological Museum.
A skull dating from before 1666.

La Rochelle
Museum d'Histoire Naturelle.
Fairly complete skeleton purchased
from Deyrolle, Paris,1934.

Leiden
National Museum of Natural History.
Some separate skeleton material.

London
Natural History Museum.
Two reconstructed skeletons.
Origin: Mare Aux Songes 1866-1871.
Right leg, dating from before 1681.
Separate bones from Mare Aux Songes.
Reconstructed skeleton from the legacy
of Lord Rothschild (Tring).

Royal College of Surgeons.
Incomplete reconstructed skeleton.

Lyons
Museum d'Histoire Naturelle.
Reconstructed skeleton.

Mauritius
Mauritius Institute, Port Luis.
Three reconstructed skeletons.
Origin: Mare Aux Songes 1865 & 1889.
Large amount of Dodo material.
Origin: Mare Aux Songes and locations
investigated by private collectors.

New York
American Museum of Natural History.
Fairly complete skeleton, purchased 1905.
Separate skeleton parts.

Oxford
Oxford University Museum.
Head and right foot, from before 1683,
removed from stuffed Dodo in 1755.
Reconstructed skeleton (Derek Frampton
1998). Separate skeleton parts.

Paris
Museum d'Histoire Naturelle.
Reconstructed skeleton. Origin: auction
of Mare Aux Songes material in London,
March 1866. Separate skeleton material.

Perth
Western Australian Museum.
Reconstructed skeleton.

Prague
Narodny Museum, Natural History
Department. Upper and lower beak,
probably dating from before 1607.
Some separate bone material.

Stuttgart
Reconstructed skeleton.

Washington
National Museum of Natural History.
Reconstructed skeleton, purchased 1905.
Some separate bone material.

Vienna
Natural History Museum.
Incomplete, reconstructed skeleton,
purchased 1905.

Zanzibar
Highly incomplete, incorrectly reconstructed
skeleton.

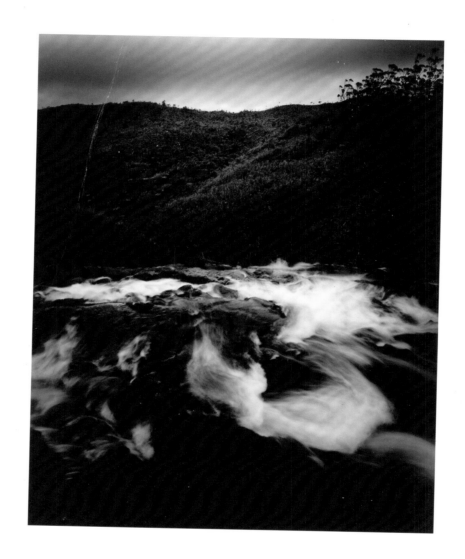

Combo Nature Reserve #4, Mauritius, 2004